IT CHOOSES YOU

–

MIRANDA JULY

–

WITH PHOTOGRAPHS BY
BRIGITTE SIRE

McSWEENEY'S
SAN FRANCISCO

www.mcsweeneys.net

Copyright © 2011 Miranda July

Photographs on page 209 by Aaron Beckum.

Typographic direction by Project Projects.

The interviews and sequences within have been edited for length, coherence, and clarity.

ISBN: 978-1-938073-01-4

FOR JOE AND CAROLYN PUTTERLIK

I slept at my boyfriend's house every night for the first two years we dated, but I didn't move a single piece of my clothing, a single sock or pair of underwear, over to his place. Which meant I would wear the same clothes for many days, until I found a moment to go back to my squalid little cave, a few blocks away. After I changed into clean clothes I'd walk around in a trance, mesmerized by this time capsule of my life before him. Everything was just as I'd left it. Certain lotions and shampoos had separated into waxy layers, but in the bathroom drawer there were still the extra-extra-large condoms from the previous boyfriend, with whom intercourse had been painful. I had thrown away some foods, but the nonperishables, the great northern beans and the cinnamon and the rice, all waited for the day when I would remember who I really was, a woman alone, and come home and soak some beans. When I finally put my clothes in black plastic bags and drove them over to his house, it was with a sort of daredevil

spirit — the same way I had cut off all my hair in high school, or dropped out of college. It was impetuous, sure to end in disaster, but fuck it.

I've now lived in the boyfriend's house for four years (not including the two years I lived there without my clothes), and we're married, so I've come to think of it as my house. Almost. I still pay rent on the little cave and almost everything I own is still there, just as it was. I only threw out the extra-extra-large condoms last month, after trying hard to think of a scenario in which I could safely give them to a large-penised homeless person. I kept the house because the rent is cheap and I write there; it's become my office. And the great northern beans, the cinnamon, and the rice keep the light on for me, should anything go horribly wrong, or should I come to my senses and reclaim my position as the most alone person who ever existed.

This story takes place in 2009, right after our wedding. The story of us now felt like the real plot of my life, which was, terrifyingly, the most incredible, joyful thing that had ever happened to me. I had once feared that love would take me away from my solitary world of work; now I often regretted that it hadn't. There was still a dogged insistence on going to the little house each day, as cold and miserable as it was. I worked on my screenplay at the kitchen table, or in my old bed with its thrift-store sheets. Or, as anyone who has tried to write anything recently knows, these are the places where I set the stage for writing but instead looked things up online. Some of this could be

justified because one of the characters in my screen-
play was also trying to make something, a dance, but
instead of dancing she looked up dances on YouTube.
So, in a way, this procrastination was research. As if
I didn't already know how it felt: like watching myself
drift out to sea, too captivated by the waves to call
for help. I was jealous of older writers who had gotten
more of a toehold on their discipline before the web
came. I had gotten to write only one script and one
book before this happened.

The funny thing about my procrastination was
that I was almost done with the screenplay. I was like
a person who had fought dragons and lost limbs and
crawled through swamps and now, finally, the castle
was visible. I could see tiny children waving flags on
the balcony; all I had to do was walk across a field to
get to them. But all of a sudden I was very, very sleepy.
And the children couldn't believe their eyes as I folded
down to my knees and fell to the ground face-first,
with my eyes open. Motionless, I watched ants hurry
in and out of a hole and I knew that standing up again
would be a thousand times harder than the dragon or
the swamp and so I did not even try. I just clicked on
one thing after another after another.

The movie was about a couple, Sophie and Jason,
who are planning to adopt a very old, sick stray cat
named Paw Paw. Like a newborn baby, the cat will
need around-the-clock care, but for the rest of his

life, and he might die in six months or it might take
five years. Despite their good intentions, Sophie and
Jason are terrified of their looming loss of freedom.
So with just one month left before the adoption,
they rid their lives of distractions — quitting their
jobs and disconnecting the internet — and focus on
their dreams. Sophie wants to choreograph a dance,
and Jason volunteers for an environmental group,
selling trees door-to-door. As the month slips away,
Sophie becomes increasingly, humiliatingly paralyzed.
In a moment of desperation, she has an affair with
a stranger — Marshall, a square, fifty-year-old man
who lives in the San Fernando Valley. In his suburban
world she doesn't have to be herself; as long as she
stays there, she'll never have to try (and fail) again.
When Sophie leaves him, Jason stops time. He's stuck
at 3:14 a.m. with only the moon to talk to. The rest
of the movie is about how they find their souls and
come home.

Perhaps because I did not feel very confident
when I was writing it, and because I had just gotten
married, the movie was turning out to be about faith,
mostly about the nightmare of not having it. It was
terrifyingly easy to imagine a woman who fails herself,
but Jason's storyline confounded me. I couldn't figure
out his scenes. I knew that in the end of the movie
he would realize he was selling trees not because he
thought it would help anything — he actually felt it
was much too late for that — but because he loved
this place, Earth. It was an act of devotion. A little

like writing or loving someone — it doesn't always feel worthwhile, but not giving up somehow creates unexpected meaning over time.

So I knew the beginning and the end — I just had to dream up a convincing middle, the part when Jason's soliciting brings him in contact with strangers, perhaps even inside their homes, where he has a series of interesting or hilarious or transformative conversations. It was actually easy to write these dialogues; I had sixty different drafts with sixty different tree-selling scenarios, and every single one had seemed truly inspired. Each time, I was convinced I had found the missing piece that completed the story, hilariously, transformatively. Each time, I had chuckled ruefully to myself as I proudly emailed the script to people I respected, thinking, Phew, sometimes it takes a while, but if you just have faith and keep trying, the right thing will come. And each of those emails had been followed by emails written a day, or sometimes even just an hour, later — "Subject: Don't read the draft I just sent you!! New one coming soon!!"

So now I was past faith. I was lying in the field staring at the ants. I was googling my own name as if the answer to my problem might be secretly encoded in a blog post about how annoying I was. I had never really understood alcohol before, which was something that had alienated me from most people, but now I came home from the little house each day and tried not to talk to my husband before I'd had a thimbleful of wine. I'd been vividly in touch with myself for thirty-five

years and now I'd had enough. I discussed alcohol with people as if it were a new kind of tea I'd discovered at Whole Foods: "It tastes yucky but it lowers your anxiety, *and* it makes you easier to be around — you have to try it!" I also became sullenly domestic. I did the dishes, loudly. I cooked complicated meals, presenting them with resentful despair. Apparently this was all I was capable of now.

I tell you all this so you can understand why I looked forward to Tuesdays. Tuesday was the day the *PennySaver* booklet was delivered. It came hidden among the coupons and other junk mail. I read it while I ate lunch, and then, because I was in no hurry to get back to not writing, I usually kept reading it straight through to the real estate ads in the back. I carefully considered each item — not as a buyer, but as a curious citizen of Los Angeles. Each listing was like a very brief newspaper article. News flash: someone in LA is selling a jacket. The jacket is leather. It is also large and black. The person thinks it is worth ten dollars. But the person is not very confident about that price, and is willing to consider other, lower prices. I wanted to know more things about what this leather-jacket person thought, how they were getting through the days, what they hoped, what they feared — but none of that information was listed. What was listed was the person's phone number.

On one hand was my fictional problem with Jason and the trees, and on the other hand was this telephone number. Which, normally, I would never have

called. I certainly didn't need a leather jacket. But on this particular day I really didn't want to return to the computer. Not just to the script, but also the internet, its thrall. So I picked up the phone. The implied rule of the classifieds is you can call the phone number only to talk about the item for sale. But the other rule, always, is that this is a free country, and I was trying hard to feel my freedom. This might be my only chance to feel free all day.

In my paranoid world every storekeeper thinks I'm stealing, every man thinks I'm a prostitute or a lesbian, every woman thinks I'm a lesbian or arrogant, and every child and animal sees the real me and it is evil. And they're not wrong; I have been all these things at one time or another. So when I called I was careful to not be myself; I asked about the jacket in a voice borrowed from the Beav on *Leave It to Beaver*. I was hoping for the same kind of bemused tolerance that he received.

The person who answered was a man with a hushed voice. He wasn't surprised by my call — of course he wasn't, he had placed the ad.

"It's still for sale. You can make an offer when you see it," he said.

"Okay, great."

There was a pause. I sized up the giant space between the conversation we were having and the place I hoped to go. I leaped.

"Actually, I was wondering if, when I come over to look at the jacket, I could also interview you about your life and everything about you. Your hopes, your fears..."

My question was overtaken by the kind of silence that rings out like an alarm. I quickly added: "Of course, I would pay you for your time. Fifty dollars. It'll take less than an hour."

"Okay."

"Okay, great. What's your name?"

"Michael."

MICHAEL

–

LARGE BLACK LEATHER JACKET
$10

–

HOLLYWOOD

–

It was wonderful to have this opportunity to leave my
cave. I packed a bag with yogurt, apples, bottles of
water, and a little tape recorder. It was the kind that
used mini-tapes; I'd gotten it when I was twenty-six in
order to listen to the tapes the director Wayne Wang
sent me after he recorded our conversations about
my sexual history as part of his research for a movie
he was making. I had always thought of this as a rather
creepy exercise that I'd participated in for the money
and because I liked to talk about myself. But now, put-
ting the tape recorder in my purse, I felt a little more
sympathetic. Maybe Mr. Wang had just wanted to talk
to someone he hadn't made up. Maybe it was a casu-
alty of the job.

I drove to Michael's with a photographer, Brigitte,
and my assistant, Alfred. Brigitte had met all my family
and friends, but I hadn't known her very long, or very
well — she was our wedding photographer. Her photo-
graphic equipment legitimized this outing in my mind;

maybe I was a journalist or a detective — who knew?
Alfred was there to protect us from rape.

The address was a giant old apartment building on
Hollywood Boulevard, the kind of place where starlets
lived in the '30s, but now it was the cheapest sort of
flophouse. It's not that my world smells so good — my
house, the houses of my friends, Target, my car, the
post office — it's just that I know those smells. I tried
to pretend this too was a familiar smell, the overly
sweet note combined with something burning on a
hotplate thirty years ago. I also tried to appreciate
small blessings, like that when we pressed 3 on the
elevator, it went up and opened on a floor with a cor-
responding number 3.

The door opened and there was Michael, a man
in his late sixties, burly, broad-shouldered, a bulbous
nose, a magenta blouse, boobs, pink lipstick. Before
he* opened the door completely he quietly stated that
he was going through a gender transformation. That's
great, I said, and he asked us to please come in. It was
a one-bedroom apartment, the kind where the living
room is delineated from the kitchen area by a metal
strip on the floor, joining the carpet and the linoleum.
He showed us the large leather jacket and I felt a little
starstruck: here it was, the real thing. I touched its
leather and immediately got a head-rush. This some-
times happens when I'm faced with actualities — it's
like déjà vu, but instead of the sensation that this has
happened before, I'm suffused with the awareness
that this is happening for the first time, that all the

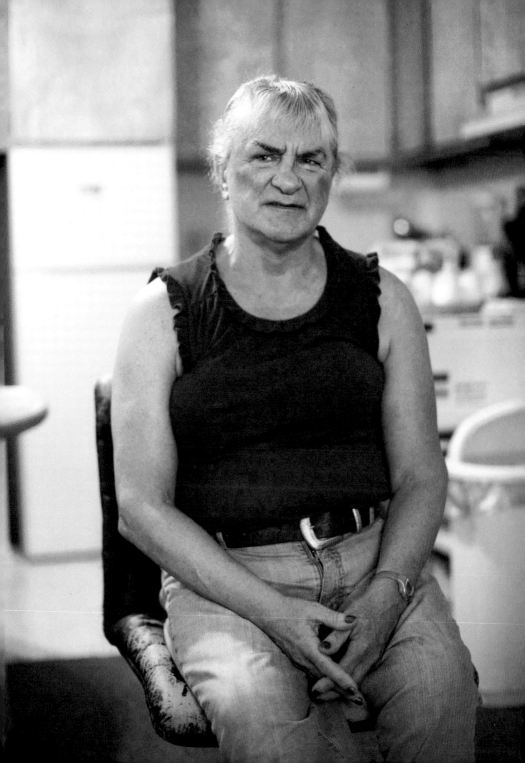

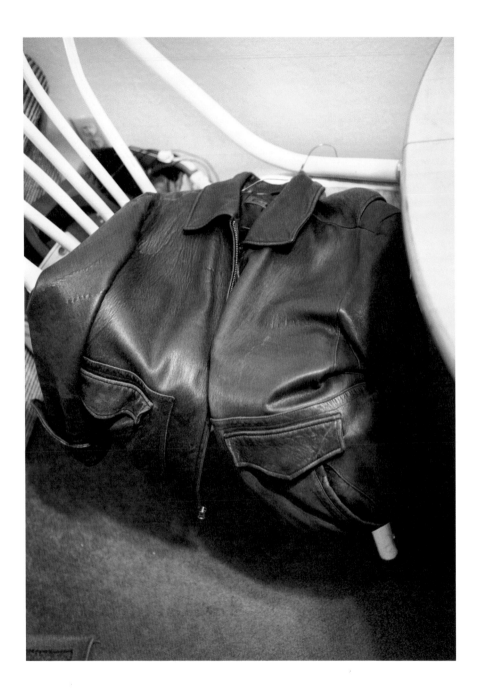

other times were in my head.

We murmured admiration for the jacket, which was entirely ordinary, and I asked if I could turn on the tape recorder. Michael settled into a medical-looking chair and I perched on the couch. I glanced at my questions, but now they seemed beside the point.

Miranda: When did you begin your gender transformation?

Michael: Six months ago.

Miranda: And when did you know that you —

Michael: Oh, well, I knew it when I was a child, but I've been in the closet all my life. I came out in 1996 and then went back in the closet again, but this time I'm not going to go back in the closet. I'm going to complete the transformation.

Miranda: So the first time you came out must have been hard. You must not have had a good experience?

Michael: It wasn't hard. I just decided to do it, and I don't know why I went back in the closet. It's one of those psychological things that I'm going to a psychologist to work out.

Michael spoke softly and with a sort of evenness that made me wonder if he was a little bit drugged. Nothing crazy, maybe just some muscle relaxers to take the edge off. The thought calmed me — I was glad there was some padding between him and my invasive questions. I wished I was on muscle relaxers too.

Miranda: What was your life like before you came out?

Michael: I was trying to be the same as every other man, and hiding the fact that inside I felt like a woman. I knew that when I was a child, but I had this strong fear of coming out for a long time. The movement for gay people to come out helped me realize that I shouldn't do that.

Miranda: What did you do for a living?

Michael: I ran my own business as an auto mechanic.

Miranda: What do you do now?

Michael: Now I'm retired.

Miranda: What are you living on?

Michael: On Social Security benefits. This is a Section 8 building, so rent is very reasonable. And before this building I lived in the cheapest rooming house in Hollywood.

Miranda: And how do you spend your days?

Michael: I go shopping and watch television, and I go for walks for my health.

Miranda: What shows are your favorites?

Michael: *The Price Is Right* and the news.

Miranda: And do you feel like you have a community here?

Michael: I do have a community. I'm going to Transgender Perceptions meetings every Friday at the Gay and Lesbian Center on McCadden, and there's a bunch of other transgender people that go. Male-to-female, female-to-male. There's two I met there that had their major surgeries forty years ago.

I asked if we could look around his apartment and he said sure. Michael stayed seated and watched us as we walked around, quietly peering at everything.

It reminded me of being at a garage sale, the rude feeling of surveying someone's entire life in one greedy glance. Every few seconds I raised my eyebrows with reassuring interest, but Michael was not concerned.

Miranda: Can I look at your movie collection?

Michael: Oh, that's all pornography.

I nodded and smiled warmly to indicate how okay I was with pornography.

Michael: You can look through it.

I knelt down and studied the tapes. They were all of women, or what seemed to be women. I did one of those modern calculations: male-to-female + porn for straight men = he wants to be lesbian?

Miranda: Is it women that you like?

Michael: Well, there's straight pornography and there's trans pornography. There's also some pornography with she-males too. And that's about it.

This answer just created more questions, but I was too shy to ask them. I took my pre-written questions out of my pocket.

Miranda: Have you ever had a computer?

Michael: No, I've never had any computers. I may get one someday. I use the computer at the library.

Miranda: Is there anything you want that you worry you'll never have?

Michael: No, not at this age.

Miranda: You feel like you've come to peace with things?

Michael: Yeah. The only thing left is my completed transition; that's the only thing left that I'm desiring. I'm waiting for that.

Miranda: And what would you say has been the happiest time in your life so far?

Michael: Oh, I just enjoy living. I'm always happy. I can't say between one or the other which is the happiest time. I never thought about that.

Miranda: Not everyone enjoys living — is that just part of the spirit you were born with, or do you think your parents instilled that?

Michael: No. It's part of my spirit that I was born with. I was never taught that idea.

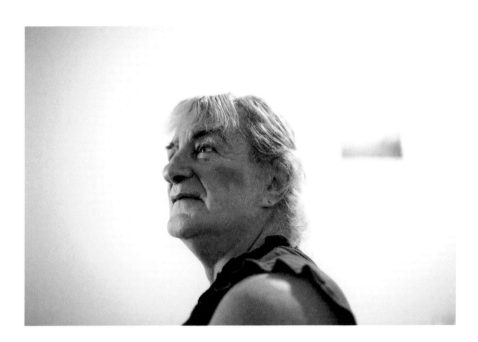

I threw a question mark at Brigitte and she nod-
ded yes, she'd photographed everything. So we said
goodbye to Michael, nervously heaping on parting
graces, and silently rode the elevator back down to
the first floor. We stepped out onto sunny Hollywood
Boulevard, a street I drive down every day. Now when
I drove past this building I would always know that
Michael was in there, living on Social Security benefits,
enjoying life and desiring only one last thing — to trans-
form into a woman. His conviction ignited me. I felt
light and alert. Evidence of his faith in this almost-im-
possible challenge was everywhere: the pink blouse, the
makeup littering the bathroom, the handmade dildo-
esque wig stand. These were not signals of defeat. This
was not someone who was getting sleepy at the end
of his journey; in fact, everything he had lived through
made him certain of what mattered now.

I had become narrow and short-sighted at my
desk. I'd forgotten about boldness, that it was even
an option. If I couldn't write the scenes, then I should
really go all the way with not writing them. I decided
to remove myself from my computer and the impli-
cation that I might be on the verge of a good idea.
I would meet with every *PennySaver* seller who was
willing. I would make myself do this as if it were my
job. I would get a better tape recorder and drive all
over Los Angeles like an untrained, unhelpful social
worker. Why? Exactly. This was the question that my
new job would answer.

I had to force myself each time I dialed a

stranger's number, but I made myself do it, because
this was the end of the road for me; not calling would
be the beginning of not doing a lot of other things, like
getting out of bed. I started with the first item for sale
(a pair of matching silver champagne flutes engraved
with the year 2000, twenty dollars) and made my way
down the list. Most people didn't want to be inter-
viewed, so when someone said yes I felt elated, as if
they had said, "Yes, and after you pay me fifty dollars
for the interview, I'll pay *you* one-point-five millon
dollars to finance your movie." Because that was the
other problem I was now having. In the time it had
taken me to write the movie, the economy had turned
to dust. Suddenly all the companies that had been
so excited to meet me a year ago were not financing
anything that didn't star Natalie Portman. Which kind
of brought out the Riot Grrrl in me — I walked out of
polite meetings in Beverly Hills with visions of turning
around and walking back in, naked, with something
perfect scrawled across my stomach in black marker.
But what was the perfect response to logical, cautious
soulessness? I didn't know. So I kept my clothes on
and drove to the home of someone who *had* said yes
to me, sight unseen. A woman selling outfits from India
for five dollars each.

*At the time of this interview, he referred to himself as Michael and
still used the pronoun *he*; later, she changed her name to Suzette and
now uses the female pronoun. So my pronoun here is debatable.

PRIMILA

–

OUTFITS FROM INDIA
$5 EACH

–

ARCADIA

–

I had presumed that very wealthy people didn't use the *PennySaver*, but as we drove up to a house with turrets and perhaps even balustrades, depending on what those are, I reconsidered my presumption. And as I listened to the long tones of Primila's musical doorbell, I considered reconsidering everything — my sexuality, my profession, my friends; they were all up in the air for as long as the chimes pealed. Was this what church sounded like? What if I became born-again right now? I crossed my arms to keep this from happening and reminded myself to be attentive to mysterious advice and coded messages. In any vision quest–type scenario, one had to be very alert; I was keeping an ear out for something like "The trees have eyes." It would make no sense at the time, but later it would save my life.

A middle-aged Indian woman opened the door. She wasn't wearing an outfit from India, just a nor-mal suburban-mom outfit. She held a flyswatter and

warmly welcomed us inside while savagely slapping flies.

Miranda: Thank you so much for having us here.

Primila: So do you want to tell me again a little bit more about what this is for? Do you have any brochure or write-up on things that you do, or your company?

Miranda: I'm just interviewing people. I'm really interested in just getting a portrait of the person and what they're interested in, and a sense of their life story. I'm a writer and I usually write fiction, but this is — you know, I'm always curious about people. So this is a chance to —

Primila: You write fiction? Do you have any particular themes or any commission or fashion?

Miranda: They're — I mean, gosh. They're usually about people trying to connect in one way or another and the importance of that. And the different ways people sort of make that harder than it needs to be.

Primila: I'm just curious, because out of the blue —

Miranda: I know, I know. So, I know you told me a little bit on the phone, but now that I'm recording, what led to you putting — what are you selling in the *PennySaver*?

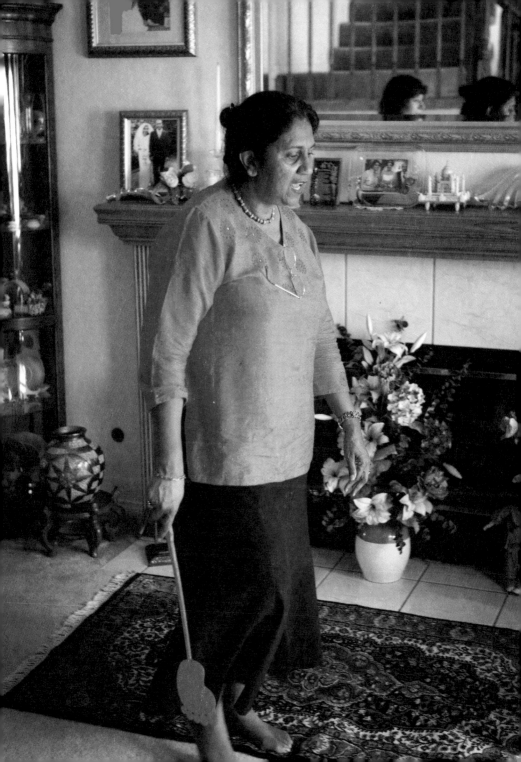

Primila: What I'm selling are some outfits from India. I have quite a few of them. I'm trying to do two things. One is get them to people who would probably appreciate it who normally wouldn't have a chance to have this kind of ethnic costume. But the whole thing started, I think it was a year ago in July. We had gone to India, and we went to a village. My husband has a special interest in that place because his grandmother hailed from that village. Of late, because of the lack of rainfall and because of all that, the crops have been failing. These people from the village said, "Can you help us and send us money? We need a motorized irrigation system."

So I had an open house and sold all these Indian outfits that I brought from India. I did that for two days, two Saturdays, and I raised about... I think it was a few hundred, and I sent it all there, and they got this motorized pump.

In April my husband went back, and they're very happy with the irrigation system but now they want to expand their fields. I thought, Let me put an ad in the *PennySaver* and maybe I will reach people who want to buy the stuff. One lady came, and she got a lot because she works as an extra in the movies and she's a Latino lady. She said

sometimes they want her to dress up as an Indian lady. So she loved that.

Miranda: Where in India are you from?

Primila: Bombay. My dad was a meteorologist at the Bombay airport. So we built a house right near the airport. A huge, big three-story house.

Miranda: And can you tell me your earliest memory?

Primila: Yes. I was two years old. I was traveling on a ship from Bombay to England. It was like a big doll's house. In those days people didn't fly, they went by cruise liners. I was just two and I can remember so clearly. My name is Primila, but I would tell everyone my name is Mrs. Haggis. I don't know why or how. My mom tells the story of how this little girl — I had ringlets — there would be a group around me saying, "What's your name, little girl?" And I'd say, "Mrs. Haggis." I insisted that was my name.

I'd never even eaten haggis, so I don't know where it — or maybe I'd heard about haggis and I thought, you know, that's an English dish.

Primila showed me around her house. It was immaculate and girlish, with white carpet and

arrangements of large dolls dressed in frilly dresses. And though she knew I wasn't a reporter or anyone of consequence, she began to tell me about herself the way Michael had, as if this interview really mattered. It occurred to me that everyone's story matters to themselves, so the more I listened, the more she wanted to talk.

Primila: I write poems with a theme or a message. "Each Day Is a Gift" was a theme. Then after Thanksgiving I wrote "Ten Reasons to Be Thankful." There's another one, "Look for the Rainbow" — because I've had so many things happen and I try always to still be upbeat and positive, no matter what. I lost my sister very tragically to cancer years ago. She had fourth-stage colon cancer. She was thirty-five years old with four little kids. They wouldn't give her the visa to come to America, and she was in the last month. I talked to the embassy in India and every time it was no, no, because they didn't believe it — she looked so healthy and so they didn't believe.

It was Thanksgiving here in America. So the next day I woke up and I said I'm going to call the top official. His name was Tom Fury, I still remember. And they'd never let you through. It was all this hierarchy of people. Finally he

came on the phone and I said, "Mr. Fury, I just want to tell you one thing. If my sister doesn't make it, I'll be at peace because I've done everything I can. And she knows how much we love her." But I said, "Whoever has been instrumental in denying her this last opportunity will have to live with that for the rest of their lives and will have to answer for that on the Day of Reckoning." That's all I said, and "Thank you so much." And this had been going on for three months, not granting the visa.

At 2 a.m. the phone rang. It was my mom in India. "Primila, you won't believe this. The embassy called. They've granted the visa to the whole family." And when my brother went down to get the visa, they said this had never happened before in the history of the embassy.

She passed away on December 24. We buried her on December 31 at Forest Lawn. Then I kept her children and raised them. So whatever happens, I always try to share things that we can learn from what happens in our lives, how we can help others.

Miranda: And what do you do for a living?

Primila: I'm director of rehabilitation at a hospital. I've worked there twenty-three years. I'm so

passionate about my work that in twenty-
three years I've never had an unscheduled
absence. I never picked up and said, "I'm not
coming in today." But today I locked my door
— I always lock my bedroom door when my
husband's in India — and I realized my purse
was still inside with the car key. I didn't know
what to do. I went up and I shook the door.
It wouldn't open. So I thought, What do I do?
Let me call my son. My son tells me, "Mom,
you've never called in sick. I'm busy. Maybe
today's the first time in your life — you have
a reason: you don't have a car." I said, "Are
you kidding? I would never do that." The day
I drop dead I won't show up at work. So I
went up again and I just shook the door and I
managed to budge it.

Miranda: You broke down the door?

Primila: Yes.

Primila took us upstairs and showed us the door,
hanging off its hinges, and then she pointed out two
places in the house where a tiny square of wall had
been removed. She asked me to guess what these holes
were for, but I said I couldn't even begin to imagine.

Primila: Okay, I'll tell you because it's a funny story.
 One day I was at work and my nephew Benny
 calls me and he says, "Auntie, I'm hearing

voices from the wall. Not from the roof, but from the actual wall." I said, "What non-sense." But when I came home I listened, and sure enough, in the closet, behind the wall — in the wall — there was a little *meow meow*. So my son-in-law cut a hole in the closet wall and he put a little food there. Then in the morning there was the cutest little black and white kitten, just two weeks old.

And then a week or two later, just behind the water heater, he calls me up and says, "Auntie, there's another *meow* going on there." And sure enough, we cut a hole there and another kitten came out. And then it happened again! There was a tree that had grown over our wall, so the cat from there had climbed up, made a hole in our roof, and got into our attic to have her kittens. And then they were falling through the insulation. My daughters are married and I'm waiting for grandchildren, but the joke is that the stork brings only four-legged babies to my house.

Before we left, she showed me how to wear a sari properly. As she wound the fabric around my hips I realized I would join the Latina actress when Primila told her story about people who had answered the ad. I had thought of myself as outrageously forward, but *PennySaver* sellers weren't hung up about inviting

strangers into their homes. So I didn't have to be so nervous — I could drop the *Leave It to Beaver* voice and focus on the secret clues each person was trying to convey to me.

That night I wrote down: (1) *Each day is a gift*, and, (2) *Look for the rainbow*. Gift. Rainbow. Primila was a hellcat, breaking down doors and threatening officials with eternal damnation. She had adopted four kids and had three four-legged grandchildren. I crossed out clues one and two. These were obviously decoy messages. Of course the truth wouldn't be sweetly concealed in a motto, because I wasn't Hansel or Gretel. My inquiry was open-ended, but it wasn't pretend, I wasn't in a fairytale or a fable. I shut my eyes and absorbed the silent *whoomp* that always accompanies this revelation. It's the sound of the real world, gigantic and impossible, replacing the smaller version of reality that I wear like a bonnet, clutched tightly under my chin. It would require constant vigilance to not replace each person with my own fictional version of them.

PAULINE & RAYMOND

–

LARGE SUITCASE
$20

–

GLENDALE

–

Pauline had been eager on the phone; she'd begun telling me about her life even before I asked the question or offered the fifty dollars. She lived in a pretty part of Glendale, my ex-boyfriend's neighborhood. As I exited at the familiar exit, I thought what if it was the same street, the same house, what if it was him selling the suitcase, what if the suitcase was mine, something I'd forgotten, and what if I bought it and inside there was myself as a child or my dad as a child, or my child as a child, the one I hadn't found time to have yet? But my ex-boyfriend's name wasn't Pauline, so we drove right past his street and parked on one a few blocks away. The house was big and grand, again. Pauline was in her seventies, and she immediately began showing me pictures and telling me stories about her amateur singing group, the Mellow Tones.

Pauline:　We sang "Two Sleepy People," "Hello Dolly"...

Miranda: What's this photo where you're holding the
 gun?

Pauline: Oh, that's me — oh, yeah. Well, in other
 words, you could call me a ham. That's my
 Cohan medley — I forgot the name of what I
 sang. "Hello My Honey," I guess. I can still sing
 but I had an operation on my ear because
 of a little growth and it turned out to be two
 cancer cells. So they had to dig harder. And
 somewhere along the line, I lost some of my
 hearing and so it comes out foggy for me. I
 don't know what I sound like. So I dropped
 out of the singing groups I was in.

Miranda: So it's your suitcase that you're selling
 through the *PennySaver*?

Pauline: The suitcase? Oh, yes, I have it in the hall-
 way. Do you want to see it?

Miranda: Maybe we should see it.

Pauline: Of course, that's what you came for.

I nodded but shrugged, to suggest that my rea-
sons for coming were ever-evolving and expanding.

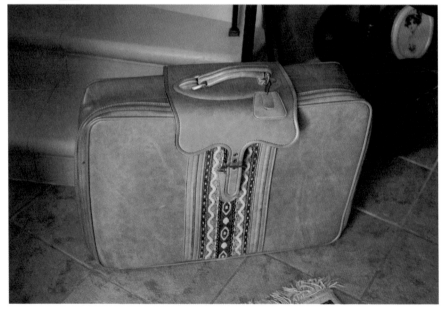

Miranda: Why are you selling it?

Pauline: Well, when my daughter and grandson moved in, a lot of things had to be sold. She said, "Where are you going to make room for my stuff?" So I had to get rid of a lot of my books and condense everything. I've sold sheets — bedsheets — and mattresses. I've sold paintings. What else did I sell? The bed.

Miranda: How do you place the ads? Do you have a computer?

Pauline: I call it in. I write up an ad — there's a special way of doing it, you get only so many words. The *PennySaver* will advertise your item for free if it's under a hundred dollars. So that's a big boost. But to sell one item at a time, it takes forever.

Miranda: And so when did your daughter and grandson move in?

Pauline: About two or three years already. Or four?

Raymond: Seven years.

This was Pauline's grandson — he had appeared out of nowhere. He was in his mid-thirties and wore a hearing aid. A very skinny dog wearing a striped rugby shirt followed him into the room.

Pauline: Seven years? You're joking. Oh, no. Where
 has the time gone?

Raymond: I started working a year later.

Miranda: Where do you work?

Raymond: I'm a driver for a company. I deliver
 mannequins.

Miranda: You deliver mannequins?

Pauline: Naked mannequins.

Miranda: Naked ones.

Raymond: We make them, we sell them, and we rent
 them. And repair them.

Pauline: He's met a few people, too, haven't you?

Raymond: I've met a lot of people.

Pauline: Celebrities.

Raymond: Not very many.

Pauline: You could name a few.

Raymond: I've met a few. Cameron Diaz — I met her,
 and Mark Jenkins.

Miranda: Neat. Do you have any pictures of you with
 mannequins?

Raymond: I have a mannequin upstairs.

Miranda: Okay, maybe we'll go up there.

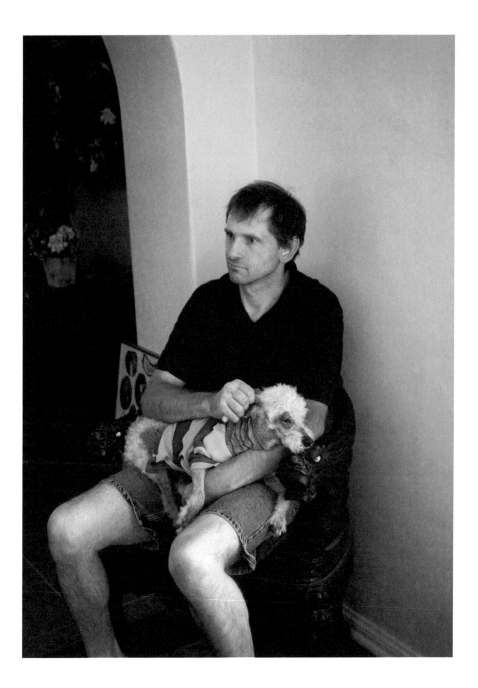

Raymond: I can bring it down.

Miranda: We can go up there. I don't want you to
 have to bring it down.

As we climbed the stairs, I began to realize the
grandeur of the house was an illusion. These were
the poor relations of the former owner. The mother
and grandson both kept food and small refrigerators
in their rooms, living in them like tiny studio apart-
ments with a shared kitchen and bathroom. Before we
looked at the mannequin, Raymond showed me a pic-
ture of himself with the actress Elizabeth Hendrickson
from *All My Children*.

Raymond: I met her at Disneyland. We had to get in
 line and we had to wait two hours.

Miranda: What is she like? What do you like about
 her?

Raymond: She's friendly. And she's beautiful, she's
 pretty.

Then he showed me the mannequin. It looked just
like Elizabeth Hendrickson.

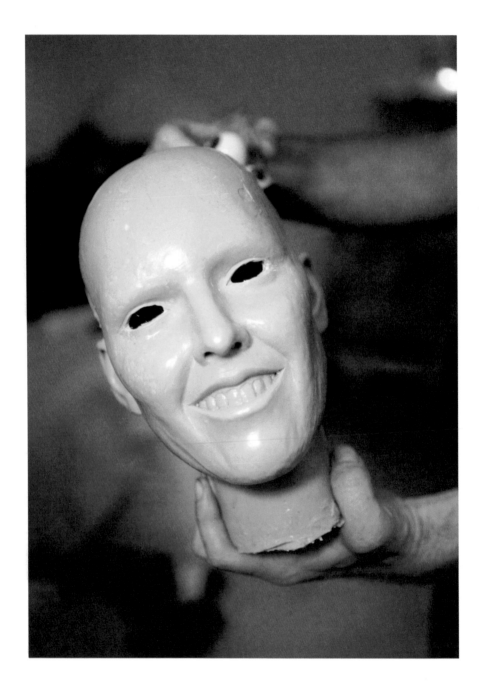

Miranda: So this — I mean, it kind of looks like her. Why does it look so much like her?

Raymond: I took this from this picture here.

Miranda: So did you make her face?

Raymond: My boss.

Miranda: Oh, your boss.

Raymond: Yeah, he made her.

Miranda: From the picture. And did he do that just for you?

Raymond: Yeah.

Miranda: Oh, that's nice.

Raymond: He put it in the mold.

Miranda: Is that expensive? I mean, did you have to buy that?

Raymond: If a regular person would buy it, it would probably be about fifteen hundred dollars. He gave me a discount.

Miranda: I see you have two computers. What do you do on your computers?

Raymond: I email. I email my friends. Sometimes I email my sister if I have a question. And I download music.

Miranda: What kind of music?

Raymond: Dido.

Miranda: She's cool.

Raymond: It's too bad Michael Jackson passed away.

Miranda: Yeah.

Raymond: I'm heartbroken because of it.

Miranda: Right before his big tour.

Raymond: That's my generation.

Miranda: How old are you?

Raymond: I'm thirty-nine.

Miranda: I'm thirty-five.

Raymond: So it's our generation.

Miranda: Right.

It was a relief, meeting someone whom I had anything at all in common with. Michael and Primila and Pauline had exhausted me with their openness and their quaint inefficiency, but Raymond and I were the same generation; we both knew how to click on things, we both had a version of our name with @ in it. As I left his room I said something like "Maybe I'll see you around," as if our generation all liked to congregate at one coffee shop.

But the moment I got back in my car I knew I would never see him again, ever. It suddenly seemed

obvious to me that the whole world, and especially Los Angeles, was designed to protect me from these people I was meeting. There was no law against knowing them, but it wouldn't happen. LA isn't a walking city, or a subway city, so if someone isn't in my house or my car we'll never be together, not even for a moment. And just to be absolutely sure of that, when I leave my car my iPhone escorts me, letting everyone else in the post office know that I'm not really with them, I'm with my own people, who are so hilarious that I can't help smiling to myself as I text them back.

Not that I was meeting one kind of person though the *PennySaver*, or that they all sold things for the same reason. Michael was poor, Pauline was lonelier than she was poor, Primila was just old-fashioned. But so far there was one commonality, something so obvious it had taken me a moment to notice. In the process of trying to reassure the people I was calling, I would occasionally mention that I was somewhat established — not a student, but a published writer. Google "Miranda July," I'd suggest (I do it all day long!). But they weren't googlers. People who place ads in the print edition of the *PennySaver* don't have computers — of course they don't, or they'd just use Craigslist.

And as I circled and crossed out ads, the newsprint booklet itself began to seem like some vestigial relic. On one future Tuesday the number of computerless people would become too small, and the booklet would simply not arrive. This made me a little

anxious, so I called up *PennySaver* headquarters and asked them if they would be around forever. "The *PennySaver* in concept will be here forever," said Loren Dalton, the president of PennySaver USA (which actually serves only California), "but not necessarily in print. That's why we've made pretty heavy invest-ments on the digital side — internet, mobile, we're getting ready to do some things with the iPad." But he assured me that nothing would happen right now, not during the recession. The *PennySaver* has always been strongest when the economy is the weakest; the first issue was printed during the Great Depression in someone's garage. The word was never trademarked, so the *PennySaver* Maryland is unaffiliated with *PennySaver* Florida and *PennySaver* Nevada. They've all started online versions of themselves in the last decade, and the print versions of all of them will be discontinued within the next decade.

So this recession was perhaps the last hurrah for the *PennySaver*. The internal slogan of the company in 2009 was "Now Is Our Time." This seemed like a pretty upbeat approach to the crisis. Just claim it! Own it. Dibs on the recession! The *PennySaver* catered to people for whom ten dollars was worth some trouble — people who saved pennies. Which, right now, was a lot of people.

ANDREW
–
BULLFROG TADPOLES
$2.50 EACH
–
PARAMOUNT
–

Now when friends asked me about how my script was going, I responded with the good news about my new job as a reporter for a newspaper that didn't exist, interviewing people I found through a soon-to-be-extinct piece of junk mail. And because I was refused by the majority of people I called, the ones I met with did not feel random — we chose each other.

Paramount was completely outside my under-standing of LA. I just did what the GPS told me to, and then I was there. It was hotter than where I lived; the blinding new pavement barely concealed the desert. I was much too early, so I drove up and down the streets, past rows of identical new houses. I could picture the man who'd built them, a hammer in one hand and the other hand hitting his forehead for the thousandth time as he stepped back from his newest creation and saw that it was, once again, exactly like the last house he'd built, the one next door. I hate it when I keep having the same bad idea, so I could empathize

with him. It seemed like a tough neighborhood for a bullfrog that was just getting started, a tadpole. I hurried back to the address, now late. I'm always late and it's always because I get there too early.

Andrew turned out to be a seventeen-year-old with three ponds in his backyard. Teenage boys never really made sense to me, and I've pretty much avoided them since high school. But Andrew was the one kind of teenage boy I was familiar with: the sweet, curious loner. My brother had also built ponds in high school. Andrew's ponds were thick with water hyacinths and the special fish that eat mosquito eggs. Actual lily pads floated in the sun and the frogs seemed happy, as suburban frogs go.

Miranda: How'd you make this?

Andrew: I just dug.

Miranda: Did you read about ponds, or how did you figure it out?

Andrew: I didn't really read about it. People just told me. Everything ended up working out little by little.

Miranda: What do you like about it?

Andrew: I don't know. It's just relaxing. Watching all this, it relaxes me a lot.

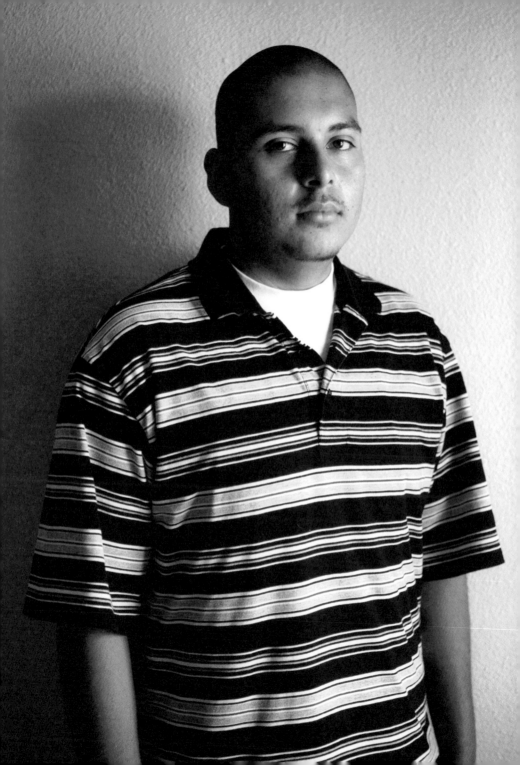

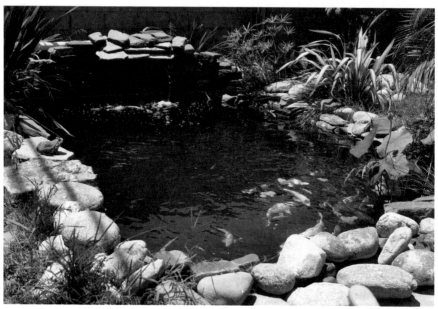

I nodded, pretending I was relaxed. I watched the sunlight sparkling on the water and practiced mind-body integration for a few seconds by quietly hyperventilating.

Miranda: Had you ever put an ad in the *PennySaver* before?

Andrew: I never really tried it. It arrives every Wednesday or Thursday. I just started looking at it and said, "Let me try that." I just wanted to try it out to see. It actually kind of did work out.

Miranda: Oh, really? Have people bought the tadpoles?

Andrew: Yeah. People enjoy them. They were kind of shocked, because nobody could really find a bullfrog tadpole.

Miranda: So the tadpoles are here?

Andrew: Let me take this plant out and you'll see.

He lifted a pile of dripping plants and scooped up a tadpole in a handful of water.

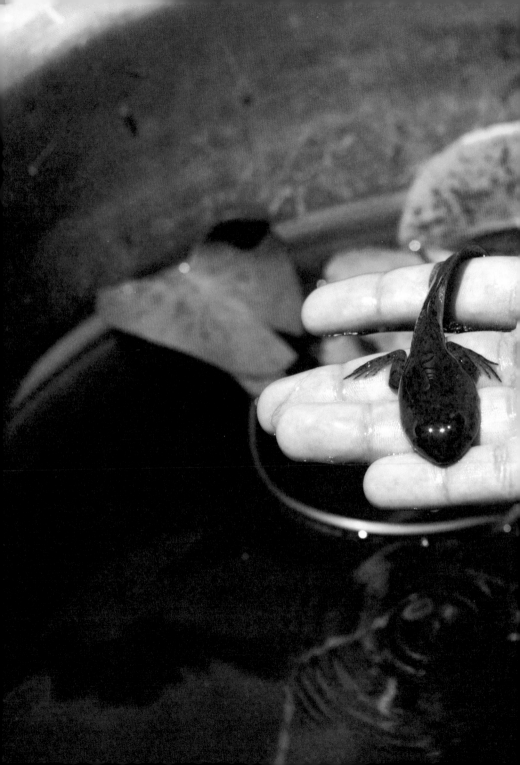

Miranda: Wow, they're really getting pretty froglike.
I thought they'd be smaller. It must be kind
of exciting, because suddenly you're going
to have a lot of — I mean, how quickly is this
happening?

Andrew: The transformation?

Miranda: Yeah.

Andrew: It's pretty fast. I'd say there are a couple of
weeks left for this one.

Miranda: Am I picturing the right kind, with the big
white thing that'll make a noise like — well,
I'm not gonna make the noise.

Andrew: Yeah.

Miranda: So that'll be kind of amazing — you'll have
this sound.

Andrew: Everywhere, yeah. It's really loud.

Miranda: That'll be kind of surprising in the
neighborhood.

Andrew watched carefully as a pigeon tried to
decide where to land and then nervously perched next
to the pond.

Andrew: Look at the pigeon. I've never seen that
before. The pond attracts wildlife. It attracts
all kinds of animals.

Miranda: Like what other kinds?

Andrew: Lizards too.

Miranda: I guess most of the city must not seem very welcoming for an animal, so this is like a little...

Andrew: Yeah, their habitat.

Miranda: What if, as we stand here, like, lions and antelopes start to come?

Andrew: That'd be crazy.

Miranda: And what do your parents do? Are they at work now?

Andrew: My dad just got laid off from the district. He used to work in Buena Park next to Knott's Berry Farm. He was a custodian. He got laid off, so now he's at home. We're spending more time with him now. My mother, she works at Kaiser.

I was burning in the sun, so we went inside, tiptoeing past the father watching TV and into Andrew's room. I instinctively shut the door behind us, because what teenager leaves their bedroom door open, ever? But then that seemed weird — I was a total stranger — so I reopened it a crack.

Miranda: Do your parents have ideas of what you should do now that you've graduated? Do you have a plan?

Andrew: Go to college, get a good education, get a career started.

Miranda: Where are you going to go?

Andrew: Long Beach. I already registered. I have the booklets and stuff.

Miranda: And what do you want to study?

Andrew: I want to get into engineering with airplanes and stuff, work with the engine or something like that. I don't know. Something using my hands, like a mechanic.

Miranda: And, besides a job, besides school and then a job, what things do you picture in your future?

Andrew: Picture?

Miranda: What do you imagine?

Andrew: Like in the future?

Miranda: Yeah, anything.

He looked at the ceiling, summoning a vision as if I had asked him to actually see his own future.

Andrew: I probably imagine myself, I guess, being

in the forest and stuff like that — in the mountains, something like that, around wildlife.

Miranda: So maybe not here.

Andrew: No, not here.

Something moved in Andrew's terrarium; I thought it was a turtle but then I looked again.

Miranda: Whoa.

Andrew: Yeah. That's my pet spider.

Miranda: Is it a tarantula?

Andrew: Yeah. He doesn't bite. It's all right.

Miranda: Okay. Good to know there's a tarantula behind me. Okay, what's been the happiest time of your life so far?

Andrew: The happiest time? I would have to say it was the graduation party my mom and my father had for me.

Miranda: I bet they were really proud.

Andrew: Yeah. They're proud. One of my goals was getting out of high school.

Miranda: Was it hard?

Andrew: Well, to me it wasn't really that hard. I was in

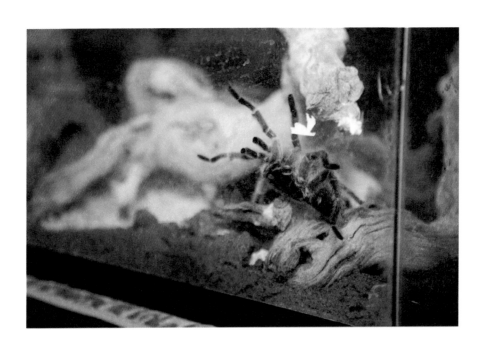

Special Ed, so the teachers don't try to take out effort from you. It's easy.

Miranda: Was it too easy?

Andrew: Too easy. It could've been harder. They don't try to teach you, because they think you won't be able to pick up the information they're giving you.

Miranda: Do you know why you're in Special Ed?

Andrew: No. I've been in it since 2000.

Miranda: So... since you were eight.

Andrew: Yeah. They just gave me my paperwork, and on the paper it says it's because I'm slow in remembering.

Miranda: Is that true?

Andrew: It says supposedly when I'm in class I'm daydreaming. I guess the teacher must think that because I don't really talk to people in my classes, because I don't know them. I just sit there and do my work and I don't talk to nobody. I guess the teacher must think I daydream because I'm not interacting with other people.

Miranda: What do you wish you'd learned more about?

Andrew: Probably science. In my science class we weren't able to do experiments. If you give

some of the Special Ed kids a knife or something, they'll play around, and I guess they didn't really trust all of us so they'd rather not give us materials to be able to do experiments and stuff. I kind of got mad at that part. We weren't able to do experiments where the other kids would do projects and stuff. We never had the chance to do that.

Miranda: And you would've been so good at biology and —

Andrew: All that stuff. It's crazy.

Miranda: It's making me mad.

Andrew: It made me mad.

Miranda: Not many people your age build a whole pond and keep everything alive. I wonder how much your college will look at those papers or if you can get kind of a fresh start.

Andrew: They're going to look at them. My counselor, she told me to turn in all that information to Special Ed services or something like that.

Miranda: It seems like it could be just as easy to be a park ranger or something like that as to work on airplanes — I mean, if you had the choice.

Andrew: I don't know, because people say it's hard. And I'm not really good with all that stuff. When I want to do something I want to know

that I can accomplish it, but if I start think-
ing that in the long run it's going to be super
hard, I kind of take a step back.

Miranda: Well, especially if you've had people telling
you that you're not good at that, it's a hard
thing to learn to finish. At least you're almost
an adult — there are some good things about
that. In high school you don't have any real
rights, but at least in college...

Andrew: Yeah. It's all on me now.

It was tempting to jump in with some advice —
I was about two seconds away from offering him an
internship at my brother's workplace, restoring wet-
lands. But it seemed be a tendency of mine to look for
each person's problem and then overlook all the other
things about them. So I tried to see what else he was,
besides lost in the system. Andrew was a little angry,
but more than that, he was proud. So I changed my
approach; I said the opposite of what I felt, and it was
more true.

Miranda: So we caught you at a kind of exciting time in
your life.

Andrew: Yeah, pretty much at a good time.

Miranda: This is corny, but you're kind of like the tad-
pole about to transform.

Andrew: Yeah. It's true.

Miranda: You're one of the big ones that have only a
 couple weeks left.

Andrew: You could say that, a tadpole.

For a moment I could feel time the way he felt it —
it was endless. It didn't really matter that his dreams
of wildlife were in the opposite direction from the
airplane hangar where he was headed, because there
was time for multiple lives. Everything could still hap-
pen, so no decision could be very wrong.

That was exactly the opposite of how I was feeling
now, at thirty-five. I drove home from Paramount feel-
ing ancient, like the characters in my script

Sophie: We'll be forty in five years.

Jason: Forty is almost fifty, and after fifty
 the rest is just loose change.

Sophie: Loose change?

Jason: Like not quite enough to get any-
 thing you really want.

I knew this wasn't really true, but that was the
paralyzing sensation. There wasn't time to make mis-
takes anymore, or to do things without knowing why.
And each thing I made had to be more impossibly
challenging than the last, which was hair-raising, since

I had been out of my depths from the very start.

The first thing I ever made professionally — that is, for the ostensible public — was a play about my correspondence with a man in prison. I started writing to Franko C. Jones when I was fourteen. I'd found his address in (where else?) the classifieds, in a section that doesn't seem to exist anymore called "Prison Pen Pals." When I was younger, my dad had read *The Minds of Billy Milligan* to me before bed, the true story of a robber and rapist with multiple personality disorder (my father's preference was to read me books that he himself was interested in). So my sympathy for imprisoned men was sort of a family tradition; I may even have written my first letter to Franko because I wanted to do something my dad would think was interesting. But then I kept writing to him for three years, every week.

The gap between a thirty-eight-year-old murderer serving his eighteenth year in Florence, Arizona, and a sixteen-year-old prep-school student in Berkeley, California, is lyrical in scale, like the size of the ocean or outer space. Bridging it seemed like one of the few things I could do that might be holy or transcendent. I've been trying for so long now, for decades, to lift the lid a little bit, to see under the edge of life and somehow catch it in the act —"it" being not God (because the word *God* asks a question and then answers it before there is any chance to wonder) but something along those lines. We wrote about grades, prison riots (Franko tape-

recorded the sounds of one), my friends (Johanna, Jenni), his friends (Lefty, One-Eye), and everything else in our lives, except for sex, which I said at the start was off-limits.

I wrote the play because I couldn't explain the relationship; conversations about it ended badly and I longed to be understood on a grand scale. I put a casting call in the free weekly newspaper, and I held auditions in a reggae club. I cast a drug-and-alcohol counselor in his thirties as Franko, and the character based on me was played by a Latina woman in her early twenties named Xotchil. (I thought I would be taken more seriously as a director if I didn't also act in it — something I keep forgetting these days.) We practiced in my attic and performed the play, *The Lifers*, at 924 Gilman Street, a punk club. I rented chairs from a church and sat in them with my friends and family and my family's friends and a few bewildered punk rockers. Together we watched this enactment of my improbable friendship and its clumsy spiritual yearning. I was so electrified with simultaneous shame and pride that two-thirds of the way through the play I got out of my seat and crept up to the side of the stage. I'm not sure what I planned to do from there — perhaps stop the show or redirect it as it happened. The drug-and-alcohol counselor gave me a hard look from the stage and I slunk back to my seat. I would simply have to endure it.

BEVERLY

–

BENGAL LEOPARD BABY
CALL FOR PRICES

–

VISTA

–

Movies are the only thing I make that puts me at the mercy of financiers, which is partly why I make other things too. Writing is free, and I can rehearse a performance in my living room; it may turn out that no one wants to publish the book or present the performance, but at least I'm not waiting for permission to make the thing. Having a screenplay and no money to make it would almost be worse than not having a screenplay and maintaining the dream of being wanted. At times it seemed that I was only pretending the script wasn't finished, to save face, to give myself some sense of control. And on a more superstitious level, I secretly believed I would get financing when I had completed my vision quest, learned the thing I needed to know. The gods were at the edges of their seats, hoping I would do everything right so they could reward me.

I had been avoiding Beverly because Vista, on the map, seemed dangerously far away. But I was

becoming more intrepid, or else my time was seeming less valuable. If, worst-case scenario, I couldn't find my way home from Vista, I could just live there. So I called Brigitte and Alfred and we set out in the morning. In between the towns and cities in California are straw-covered hills that sometimes burst into flames. Beverly lived on one of these brown hills, which made sense; you could keep a suitcase or a jacket in the city, but Bengal leopard babies would need more room.

The road was dirt, the house was surrounded by abandoned furniture and equipment, and Beverly, who met us in the lawn, was painfully lacerated. She had told me on the phone that she didn't want her face photographed because she'd just had an accident involving a shovel. The wounds were still spinning their scabs.

Beverly: Come on, I'll take you in the house and show you the cats first, and then we'll go from there. You know what this is?

She pointed to something on the wall. It had eyes.

Miranda: Yes.

Beverly: What? What is it?

Miranda: That's the butt of something.

Beverly: Yes — very good! Excellent!

Miranda: Of what, though?

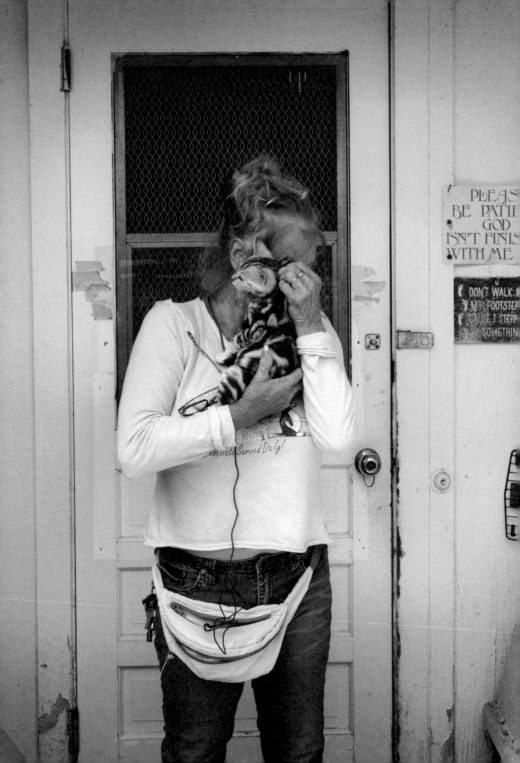

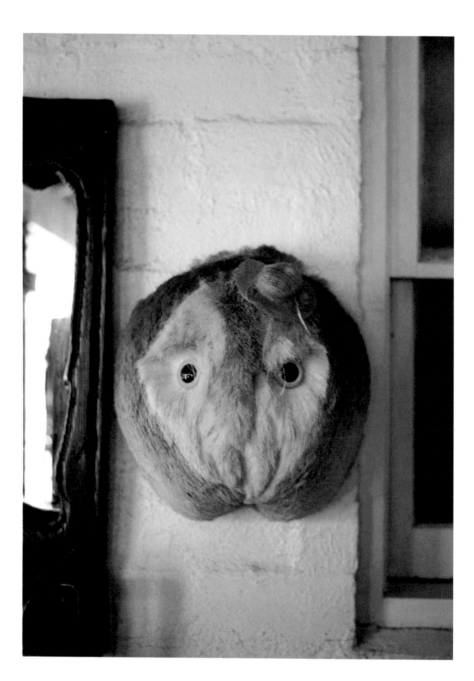

Beverly: A deer. And this bone came from Vietnam. Some man there carves it. Isn't that incredible?

Miranda: Amazing, yeah.

Beverly: It's all hand-carved. Come on. These are fish. This was from a volcano.

It was like a very questionable natural-history museum; each thing might be a million years old or it might have been made in the late '70s. But I was learning to assess people quickly, and Beverly wasn't crazy, just very glad to see us and in a hurry to get the party started. There was so much to see and do.

Beverly: Oh, and this one is dinosaur poop. And you know what this is? That's a dinosaur tooth — no, a mammoth tooth, but it's pre-mammoth. This is a picture of my second marriage. My first husband died. We were married forty years — forty and a half — and he died of cancer. It was horrible.

Miranda: I'm sorry. How long have you been with your current husband?

Beverly: Eight years.

Miranda: That's like two lives.

Beverly: Yeah, it is — two entirely different ones. This is our love.

By "love" she meant the leopards; we had just entered a fenced-off kitchen crawling with baby leopards.

Beverly: These are the girls, and I don't allow them on the table and they know better. She's a real lover, that one. This is Bonnie Blue, and she's in heat, so that's why she does a lot of yelling. Different, aren't they?

I nodded, but at first they did not seem very different or very much like leopards. Weren't leopards massive and deadly? These looked more like cute kittens. Then one of them suddenly jumped in the air to the height of my face. Two more began wrestling, slamming each other against the wall with violent cracks. They were small, but they no longer seemed cute; there was a strong man inside of each one. I tried to contemplate breeds and cross-breeds, but my knowledge was thin and I had to supplement it with what I knew about Spiderman and Frankenstein. And the Incredible Hulk.

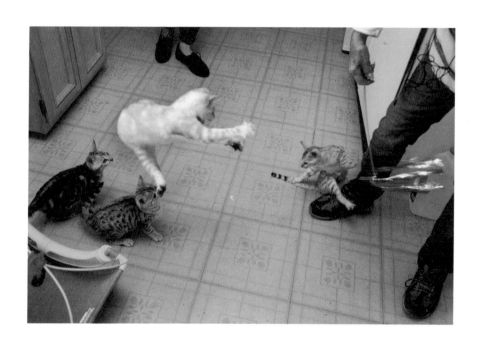

Beverly: I started this twenty years ago — 1988.
 Twenty-one years, I guess. These cats are
 bred with a British Shorthair, because the
 leopard itself is only eight to ten pounds —
 a tiny little leopard. So they're bred with a
 British Shorthair to give them some macho,
 some heavy.

Beverly took us outside to show us the bigger cats
in their cages, who shared a wall with an aviary full of
screaming birds.

Miranda: Does it drive the cats crazy that there are all
 these birds next door?

Beverly: Oh, they love it! It's their entertainment
 center.

I was fine with admiring the coop from the out-
side, but Beverly told me to hurry in before one flew
out. Dozens of birds swarmed around our heads. The
squawking and chirping were deafening.

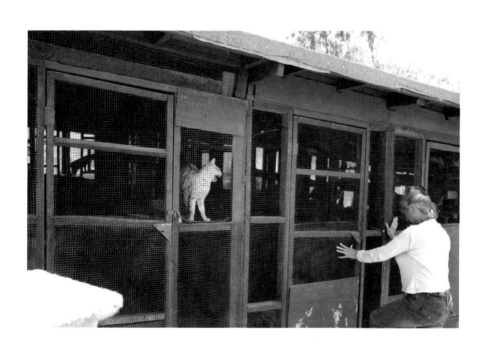

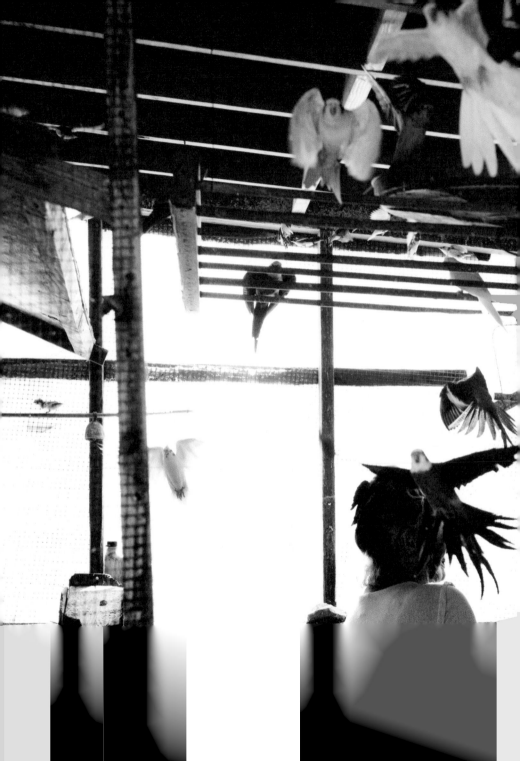

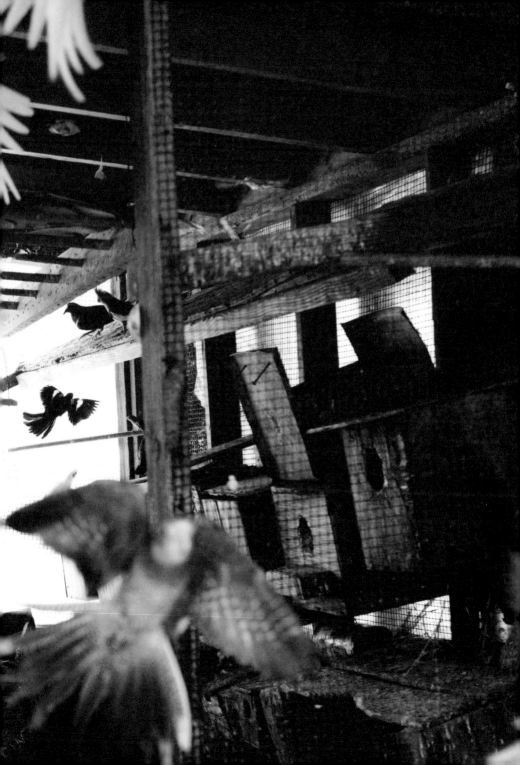

I thought about my dad's bird phobia and how unenjoyable he would find this. Then I breathed in and out slowly and pretended I was a rebellious teenager trying to differentiate myself from my parents, and in this way I was able to stay in the aviary and continue the interview.

Miranda: What kind of bird is this?

Beverly: Isn't that beautiful? And they're rare. That's a green-winged dove. There's also a bird in here called a bobo. It's black and white and it has a red beak — look for that. It sings like a canary in the morning, and it's from Africa. And the finch is so doggoned cute.

Miranda: Yeah. Really loud, isn't it?

Beverly: You get used to it after a while. Look at the colors. Our creator just has an unbelievable imagination.

The sound and smell and the wings beating around my face began to make me feel slightly hysterical, like I might cry. I also couldn't stop smiling. I should go to Mexico, I thought. Not that Beverly was Mexican, just that I'd always meant to go there. She took a baby bird out of its nest and held it in her palm. It looked like an embryo.

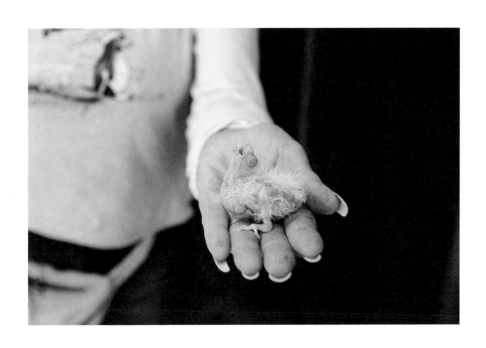

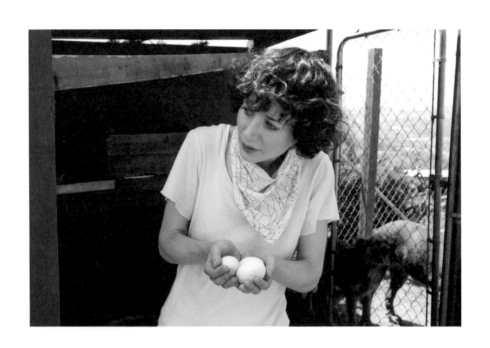

Beverly: See the way the tongue goes side to side?
 They have little polka dots in the mouth,
 and that's what attracts the mother to feed
 them. This has just been born.

Miranda: Maybe it should go back in the nest.

Beverly: Let me give you guys some eggs. You guys
 can take these with you.

Miranda: Really? Will they hatch?

Beverly: Only if you sit on them for thirty days! And
 now we have a surprise — come on.

She hurried us out of the aviary and over to a
field, where we were quickly surrounded by massive
sheep. I am not that familiar with sheep, so it took me
a moment to notice that these ones had many, many
horns, horns growing out of horns, all of them curly.

Beverly: These are the oldest breed known to man.
 They're from Israel and they're actually in
 the Bible. They're in Genesis 28 to 30 —
 they're Jacob's. Very, very special. They have
 anywhere from two to six horns.

Miranda: Yeah, they really do have a lot of horns.

Three dogs came rushing up to the fence.

Beverly: Her name is Raspberry, and then the black

one's Squooshy, and the big one is Puppy-Puppy. If you hand-feed them they're wonderful, but they're wild if you don't.

Miranda: Were these ones hand-fed?

Beverly laughed, so I laughed. I suggested we go inside, so I could interview her away from the sound of the birds. We went in the kitchen and she prepared the kittens' lunch while we talked.

Miranda: Give me a sense of your history.

Beverly: I started off with one female.

Miranda: Okay. And you're from?

Beverly: I'm from Huntington Beach.

Miranda: How long have you lived here?

Beverly: Let's see — thirty-seven years? Since '72.

Miranda: How do you make an income?

Beverly: The cats. The birds are not cutting it right now — they're just not.

Miranda: Do you notice the economy? Does that affect it at all?

Beverly: Oh, yeah. They're not buying like they used to.

Miranda: Do you have a computer?

Beverly: I do, but I don't use it.

Miranda: So no online selling — none of that.

Beverly: Uh-uh. And that's a down thing too, because everybody does it by computer now. I'm hurting my own self, but I don't have the time or the energy. I just don't. I'm not interested in computers.

Miranda: You've got a lot else to keep you busy. Do you feel like you have a community here or are you pretty isolated? What's it like in this area?

Beverly: People-wise? Yeah, I'm isolated.

Miranda: What's been the strangest part of your life so far?

Beverly: Losing my husband was the worst.

Miranda: Would you say he was the love of your life?

Beverly: Yeah.

Miranda: How old were you when you met him?

Beverly: Sixteen.

Miranda: So how did you meet him?

Beverly: At church. A very handsome man. Blue eyes, six foot two, six foot three — really sharp.

Miranda: And do you have pictures?

Beverly: I do, but I'm embarrassed. My husband, Fernando — I would feel bad for him.

Miranda: I understand.

I felt a little ashamed to have asked. And yet it would have been more romantic if she had pulled a picture of the blue-eyed husband, the one I had just suggested was the love of her life, out of her blouse. Two lives, one after the other, but the second life can never compare...

Beverly: I planned a surprise for you. His name is Sebastian, and he won't be here till four thirty.

Miranda: Oh, well, you know what — we have another interview at four thirty.

Beverly: Oh no.

Miranda: Sorry, I didn't realize that.

Beverly: I'm really sorry you can't see Sebastian. He's thirty-five pounds. He's double what we've got here. And she walks him on a leash like a dog, and it's just the darnedest thing you ever saw in your whole life. And the thing of it is she does drum rolls on him — hard. She gets in there and just pounds and he just takes it all — I don't know how, but he does. Look what I made you guys.

Beverly pulled a giant bowl of fruit salad out of the fridge. It was the kind with marshmallows; they'd

melted into the juice, turning it milky. I started to
make a polite noise of regret, but seeing her face
fall, I realized refusing was the opposite of polite. I
squeezed my iPhone in my pocket. Would it be weird
to check my email right now? Or maybe read the
news? I had an overwhelming desire to take a little
time-out. One option was a bathroom break.

Miranda: Wow, that's a lot of chopping. Could you
 point me toward the —

Beverly: Yeah — took me all morning. I can send a cup
 with you home on the road.

She had bought an enormous amount of fruit and
spent all morning chopping it. She'd asked her hus-
band to herd the biblical sheep toward us at the exact
moment we exited the aviary; she'd invited Sebastian,
the thirty-five-pound leopard. The least I could do was
eat the salad.

Miranda: Okay, give us a cup, that would be great.

Beverly: I can also do a bowl. Or cups — which would
 you prefer?

Miranda: A bowl's good. Just one bowl and we'll —

Beverly: Oh no! You each get one! Would you like
 some crackers to go with it? We like soda
 crackers with ours, crumbled on top, but it's
 up to you.

We held the dripping bowls in the car and drove
to the gas station. I made us each eat one piece
of pineapple before we threw them in the trash. It
tasted fine. I moved some newspaper over the bowls,
because what if Beverly went to get some gas and
threw something away and saw? Nothing could be
worse than that. We had gone to the place where all
living things come from; it was fetid and smelly and
cloyingly sweet, filled with raw meat and curling horns,
her face was smashed, everything was breeding and
cross-breeding, newborn or biblical. And I couldn't
take it. The fullness of her life was menacing to me —
there was no room for invention, no place for the kind
of fictional conjuring that makes me feel useful, or
feel anything at all. She wanted me to just actually be
there and eat fruit with her.

I went home and immediately fell asleep, as if
fleeing from consciousness. I woke up three hours
later and, instead of going online, I tried to pretend
I was Beverly, that I was so caught up in living things I
that didn't have "the time or the energy" for a com-
puter. The *PennySaver* didn't have quite the allure
it once did, but I sat down with the latest issue and
a pen to circle new listings. Andrew's ad was still in
there; the tadpoles had probably transitioned this
week. It seemed Michael had sold the leather jacket;
he was ten dollars closer to womanhood. Everything
was changing, except me. I was sitting in my little cave,
trying to squeeze something out of nothing. I couldn't
just conjure a fiction — the answers to my questions

about Jason had to be true, wrought from life, like all the other parts of the story.

Each character in the movie had been wrestled into existence, quickly or slowly, usually slowly and then all at once. A year earlier I had been suffering through a fruitless week when I told myself, Okay, loser, if you really are incapable of writing, then let's hear it. Let's hear what incapable sounds like. I made broken, inhuman sounds and then tried to type them, with sodden, clumsy hands. I wrote the pathetic tale of Incapable. It was long and irrelevant to my story about Sophie and Jason. Who would talk like this? Not a man or woman, no one fit for a movie.

I shut my computer gratefully at the sound of my husband's car outside. I waved from the porch as he parked, and then, with growing horror, I watched our dog jump out of the car, chasing a cat into the street as a speeding car approached. The car swerved to avoid hitting the dog, and hit the cat instead. It had happened so quickly — one moment I was writing about Incapable, and in the next moment I was putting a dead cat in a bag. He was an old, bedraggled stray, one I had seen around. I felt as though we were all complicit — me, my husband, and the driver. All of us had been careless, if not today then on another day, and all this carelessness had culminated in the death of a stranger.

When the cat was buried I finally sat back down to work and re-read the broken monologue. I felt more tenderly toward the inhuman voice now; it

wasn't really incapable, just very alone, and tired, and unwanted — a stray. I named him Paw Paw and swore I would avenge his death. He was part of the script now.

It took me a long time to figure out this cat's place in the story. Again and again it was respectfully suggested to me that I cut Paw Paw's monologue. But I couldn't kill him twice, and I thought his voice might be the distressing, ridiculous, problematic soul of what I was trying to make. Not that my conviction protected me; it's always embarrassing to pin a tail onto thin air, nowhere near the donkey. It might be wrong, it sure looks like it is — but then again, maybe the donkey's in the wrong place, or there are two donkeys, and the tail just got there first.

PAM
–
PHOTO ALBUMS
$10 EACH
–
LAKEWOOD
–

Pam could not believe we were seeing her house when it was such a mess. We assured her that it looked very clean, which it did — clean and chaotically filled with art. Gainsborough's *The Blue Boy, The Hunt of the Unicorn*, and various other familiaresque images had been meticulously re-created in needlepoint, by Pam, over the years. We settled ourselves around a large stack of albums and I lifted one onto my lap.

Miranda: Where did these come from?

Pam: One of my friends, he has a friend, and that friend have a big sale. I keep looking at the first album and the second one, and I said, "Oh my god, that's interesting. I wish I could go on vacation like this lady here."

As she talked I flipped though the album, and then another one. They were all filled with pictures of the same wealthy white couple — beginning with their

wedding in the '50s and ending with the last of their
cruises.

Pam: These people, they are going all over the
 world. To Greece and Italy and Japan, and
 it is gorgeous wherever. It really is nice,
 and someday maybe I wish I can go, but no
 money this time. My life, I get married so
 young and I have no time for vacation. And I
 say, Well, I can look at this pictures — is bet-
 ter than no vacation.

Miranda: So you don't know these people?

Pam: No, I don't know the people, but I don't want
 the albums to be thrown away. I keep almost
 like ten years actually, in my house.

 I glanced at her, wondering if she was a bit of a
hoarder. She wore a pink sleeveless top, not unlike
Michael's, and her baroque decorating style made her
seem older than she was. I guessed she was forty-
eight. An exhausted forty-eight.

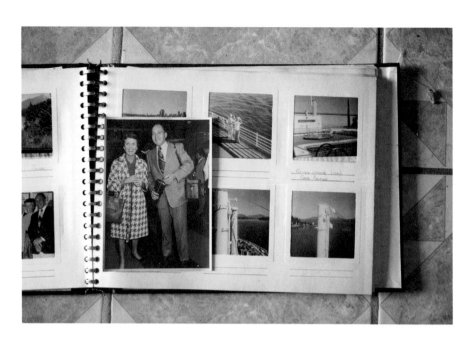

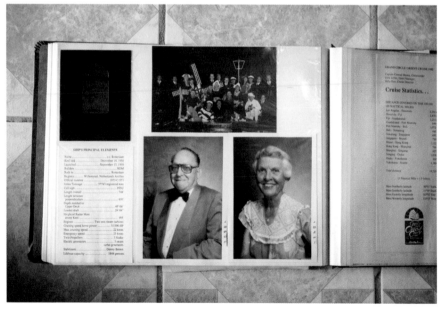

Miranda: What do you imagine their life was like?

Pam: I think they have very, very good life. Nice, happy life, actually, if you living that long.

Miranda: Yeah, they're pretty old in some of these.

Pam: Yeah, is very, very old, and is nice not only that they go, but it is nice to see them be happy with each other. Look at him, and he is just smiling, and it's nice. I always feel so good to see somebody really happy.

Miranda: Do you think they died pretty old?

Pam: Yeah, I think the lady is like ninety-five and the guy ninety, yeah.

Miranda: I'm surprised their kids wouldn't have taken these. Wouldn't you think —

Pam: They don't have kids, yeah. They don't have kids.

Miranda: So when did you move from Greece? How old were you?

Pam: I was seventeen. I got married and I come here, and then after I had three kids.

Miranda: Right away?

Pam: Yeah, after a year.

Miranda: So you were eighteen. And what did you do?

Pam: We work in restaurants, fixing food.

Miranda: So you had a restaurant?

Pam: Yeah. Twenty years one, and thirteen years
 another one.

Miranda: Wow — so twenty-three years.

Pam: Yeah, thirty-three years.

Miranda: Right, thirty-three. What would you do in the
 restaurant? What was your job?

Pam: My job was waitress, service, cashier — talk
 to the people, you know.

Miranda: Do you have a computer?

Pam: No. I don't know computer. I wish to know it,
 but I don't know.

Pam opened another album, and as we looked
at pictures of the rich, white strangers on a boat,
I had the queasy feeling that I was Pam, in reverse.
She'd invented all kinds of happiness for these people
who seemed boring to me, while her immigrant story
struck me as inherently poignant and profound. And
probably neither of us was entirely wrong; it's just
that we were, more than anything, sick of our own
problems.

Miranda: Have you ever run another ad in the
 PennySaver?

Pam: No.

Miranda: And why do you think you decided to do this
 now?

Pam: Because you know what, I need the room.

Miranda: And has anyone called about the albums to
 buy them?

Pam: Yeah, a lot of people, but —

Miranda: But they don't buy them.

Pam: Yeah. But I can't throw them out. I used to
 have one customer in the restaurant, she
 was like ninety-five years old. Her name was
 Meg. She was so sweet. She come in every
 day at eleven o'clock and she eat. And this
 lady, she's doing a job kind of like your job,
 she goes to people and takes pictures and
 talks to somebody. And then after she's
 like sixty-five years old, you know what she
 does? She takes pictures of herself every
 day. And she goes home, and she puts them
 in the scrap album. She was so careful —
 three rooms like this high, thick, thick with
 albums. And then one day she passed away.
 And the son-in-law, he take all the albums
 and put everything in the dumpster. It's so
 sad. That's why I took these albums, so they
 wouldn't get thrown in a dumpster, you
 know? That's sad to me.

At age sixty-five, an age so far past young as to be almost unfeminine, a woman had decided to photograph herself every single day. It was immediately one of my favorite works of art, all the more significant because she wasn't Sophie Calle or Tracey Emin. She knew no one would clamor for the three rooms' worth of albums; their value was entirely self-defined. And though of course I wished I had somehow saved the albums, the performance had to end with her dying and the collection being thrown into the dumpster. It was the ending that really made you think.

I bought a few of Pam's albums, and when I got home I forced myself to look at the pictures of the couple posing at alumni functions and tourist attractions. The moral of these people was clear to me: if you spend your life endlessly cruising around the world, never stopping to plant children on dry land, then when you die some Greek woman you don't even know will become the steward of your legacy. And when she wants more room in her house, she sells your legacy in the *PennySaver*. And no one wants it.

I'd been waiting for the perfect movie title, but finally I decided to just name it. It had to be short, a very familiar, short word. I looked up the most commonly used nouns. The number one most common noun was *time*. Which made me feel less alone; everyone else was thinking about it too. Number two was *person*. Number three was *year*. Number 320 was *future*. *The Future*.

I didn't set out planning to write a script about time, but the longer I took to write it and get it made, the more time became a protagonist in my life. At first my boyfriend and I thought we'd get married after our movies were made, but after about six months of trying to get the films financed we thought better of this plan and set a date, come what may. Nothing came, we got married. And then, right around the time I started blindly meeting *PennySaver* sellers, it began to dawn on me that not only was I now old enough to have a baby, I was almost old enough to be too old to have a baby. Five years left. Which is not very long if an independent movie takes at least one year to finance, one year to make, and throw in a year or two for unforeseen disasters. (And I couldn't make the movie while pregnant, even if I wanted to, because I was in it.)

So all my time was spent measuring time. While I listened to strangers and tried to patiently have faith in the unknown, I was also wondering how long this would take, and if any of it really mattered compared to having a baby. Word on the street was that it did not. Nothing mattered compared to having a baby.

And now that I had vowed to hang out with this man until I died, I also thought a lot about dying. It seemed I had not only married him but also married my eventual death. Before the vows, I might have lived alone, but forever; now I would definitely not be alone and I would definitely die. I had agreed to die, in front of all my family and friends. Brigitte had taken a

picture of the very moment: I was smiling and, under-
standably, crying. The only thing between me and
death was this child. If I delayed having the child, then
I could also delay death, sort of. So I was in a hurry
to step across the void so I could make the movie so
I could have a child before it was too late — and I was
also, secretly, not in a hurry.

I had shortened my life in another way too, by
marrying a man who was eight years older than me,
meaning he would die exactly eight years before me,
rendering the last eight years of my life useless. I
would just spend it crying.

RON
–
SIXTY-SEVEN-PIECE ART SET
$65
–
WOODLAND HILLS
–

Around this time it was kindly suggested to me that
what I really needed was not a two-hundredth draft
of *The Future*, but a movie star in a lead role to reas-
sure potential investors. This was troubling because I
already had people in mind for Jason and for Marshall,
the man my character has an affair with. They were
incredible actors who had had small parts in big mov-
ies and big parts in movies no one had seen. I tried
to point out that I hadn't cast stars in my first movie
either, and that had worked out fine. But it didn't mat-
ter, because that was 2005. You wouldn't be able to
make your first movie now, they said ominously. Which
made me feel like the recession might be able to go
back in time and take apart *Me and You and Everyone
We Know*, un-finance it, un-shoot it, un-edit it.

I began trying to think of middle-aged TV and
movie stars to play Marshall. I felt most comfort-
able with the thought of a "comeback," so I tried to
remember who the leading men were when I was a

child, and then I looked them up to see where they were now. Generally speaking, it was a motley demographic. These men had swelled up; often they had abused their wives or drugs, many had mug shots, and very few of them seemed like they would "get me." Which was appealing, because it was what the role called for — someone unlikely, almost unthinkable. And meanwhile I continued calling *PennySaver* sellers; in fact, I became more resolute about my interviews, more rebelliously determined to continue them now that I had "real" meetings, with actors.

Ron tried to convince me to interview him over the phone; he said he had his reasons for not wanting me to come over. But then he suddenly changed his mind and gave me his address. As I knocked on the door I braced myself for facelessness, or no head, or a head but no body, a head on wheels. But Ron had a body with a head and even a baseball hat. He was the most average person I'd ever seen. In preparation for our meeting, he had laid out items all over the bed and floor, brand-new books and DVDs and a sixty-seven-piece art set. They were mostly for children — *Mrs. Doubtfire* was in attendance, as was *Hop on Pop* — and they all seemed vaguely ill-gotten. The apartment was small, and he sauntered around setting up chairs for us.

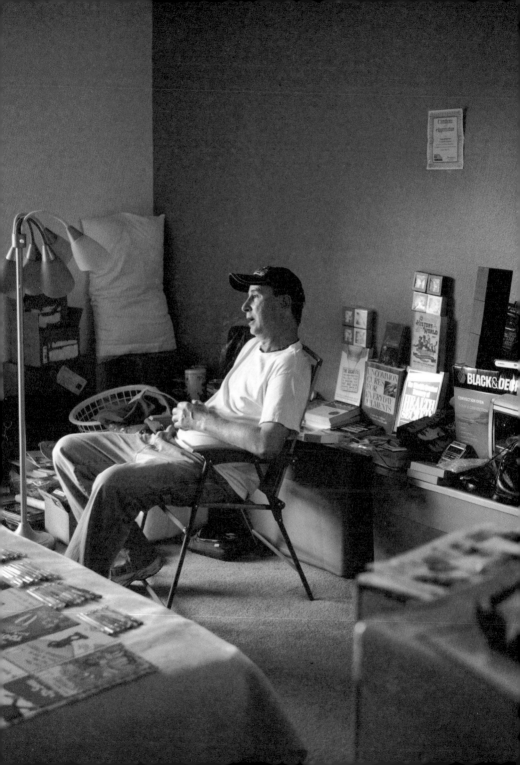

Ron: I went through a little bit of trouble to take some stuff out of my closet and throw it on here for you.

Miranda: Yeah, thank you.

Ron: Not much trouble. Just a little.

Miranda: Well, I really appreciate it. Thanks for taking the time. What did you say you do for a living?

Ron: I'm a corporate owner.

Miranda: Okay. Can you elaborate on that?

Ron: I run a financial-investment corporation. I use margin — I use the money from the banks, and then I take the money from the brokerage room at eight or nine percent only for each day that I use it. If you borrow it for a day and you sell the stock the same day — this is what people don't know — if you have ten thousand dollars, you can borrow ten thousand dollars from the brokerage firm, and then that's twenty thousand dollars. You can use that twenty thousand dollars that day and sell it the same day, and the ten thousand dollars you borrowed from the brokerage firm, you don't pay any interest.

Miranda: Okay.

I'm not especially terrific with numbers, so it was as if he'd just thrown some confetti in the air and called it words. I tried to listen harder — maybe I would really learn something here. Maybe he could explain taxes to me later.

Ron: If you hold it overnight, you owe them that money for one day, nine percent interest for just a day divided by three hundred sixty-five. So it's almost like pennies.

Miranda: Right.

Ron: It adds up if you hold it for weeks and months.

Miranda: Right, I see.

Ron: You see what I'm saying?

Miranda: Yeah.

Ron: I'm a numbers person. I've always been good with numbers. Always loved numbers. Very quick with numbers. In elementary school I was an A student up until about fifth grade, when it came to fractions. Then I had a little trouble.

Miranda: Right.

Ron: And because of that, I had what you call thousands of hours of blackjack experience when I first started in Atlantic City.

Unfortunately, I had beginner's luck. I wasn't good but I had beginner's luck. And so I won. And then after a while, I lost. And I won and I lost and I won and I lost and eventually I lost and I lost more than I won.

The discussion of blackjack was long and detailed. He tried to explain what card-counting was, why it was illegal, and how what he did was legal, even though, technically speaking, it was card-counting. Asking a question was like merging onto the freeway — I had to accelerate and jump into one of his pauses.

Miranda: What are your plans for the future?

Ron: Well, I've had a period of several years of my life that was torture and torment. And I didn't have the option to get married.

Miranda: Right.

Ron: Can you read into that?

Miranda: No.

Ron: It's about to be over in a couple of months.

Miranda: Okay.

Ron: And it was business-related.

Miranda: Okay.

Ron: Business-related Martha Stewart–type —

He lifted his pants leg a little bit to reveal a house-arrest anklet.

Miranda: Oh, okay. Okay. Right.

Ron: It's just about over.

Miranda: It'll be nice to have that off.

I said this cozily, almost maternally. The important thing was to continue behaving exactly as I had before I'd known he was under house arrest. A lot of people might have flinched, but hopefully he noticed that I had not. He leaned in toward me as if this next thing he was about to say was ultra-classified.

Ron: I'm going to tell you something that's fact.
 An anklet can mean any one of three things.
 If you're gang related, you get one on, or if
 you're a threat to the community because
 you have more than one so-called victim,
 which could be business-related or —

Miranda: Right.

Ron: — a sex offense or a drug dealer. Not small-
 time but what they consider a dealer-dealer.

Miranda: Right.

Ron: If you're any one of those four, you'll get one

of these on. People think because you have that on you're a sex-offender. Because sex-offenders have to have them on.

Miranda: Right. Right.

Ron: But the thing is, so do gang people. So do, like I said, drug dealers. So does anyone who the parole board thinks could be a threat to the community. I did do prison.

Miranda: Really. Okay. Well, what was the hardest thing about prison?

Ron: The people. The inmates. Very difficult being around so many people who are so scandalous, that'll look to take advantage of someone who's considered weak.

Miranda: Yeah. Yeah.

Ron: And to be totally honest with you, I was definitely considered to be weak. I was older. I was mellow. I was laid-back.

Miranda: Yeah.

Ron: I put on a little bit of a front the way I walked, just like when I'm outside. I walked with an attitude, so that if there's gangs or something they kind of pick up an attitude from me, like "Don't mess with me."

Miranda: Right.

Ron: I don't walk slow. I don't walk like an old man. I have a certain walk, a pace and a clip. And I always notice who's around me, and I always have done that.

Ron was exactly the kind of man you spend your whole life being careful not to end up in the apartment of. And since I was raised to go out of my way to make such men feel understood, I took extra-special care with his interview. But as he talked on and on (the original transcript was more than fifty pages), I realized that I don't actually want to understand this kind of man — I just want them to *feel* understood, because I fear what will happen if I am thought of as yet another person who doesn't believe them. I want to be the one they spare on the day of reckoning.

Brigitte had stopped taking pictures and was hanging out near the door with wide eyes. Alfred had become very still and silent somewhere behind me.

Miranda: What do you love to do?

Ron: I love to sing.

Miranda: What do you like to sing?

Ron: I like — for example, there's a song called "A Teenager in Love."

Miranda: The Everly Brothers?

Ron: Dion and the Belmonts, or maybe just Dion.

Sometimes I really feel like I want to belt it out and just release that tension.

Miranda: Yeah — people who sing, it's like they can pour out emotion in a way that other people can't.

Ron: Well, I tell you — here's the bottom line of what people have always told me. They said I've always been good with kids. I worked in Reseda through a court-order monitor — when the husband had a court order for the wife that required somebody to be there for the kids, or the wife had an order, I was the one there. So that shows you how risky of a person I am, okay?

Miranda: Yeah. Yeah.

Ron: The court checked my background out. I did that in the '80s part-time. And I actually had a problem because a lot of the kids were requesting me and the agency says, "Hey, Ron. There's too many people requesting you."

Miranda: Yeah.

Ron: I'm good with kids. I know how to get down on their level and enjoy myself with them. Not a Michael Jackson type, but —

Miranda: No, I understand. What's been the happiest

time in your life so far?

Ron: A happy time was when I had a three-year
 relationship with a younger girl when I was
 twenty-six, a girl that I truly, truly loved. But
 she was too young to marry. And I told her,
 "In a couple of years, when you're eighteen,
 if you feel that way, let me know then." But
 I knew she would spread her wings and see
 what life was all about. I was smart enough
 to know that.

Miranda: So that was a happy time?

Ron: That was a really happy time. Another good
 time was being with a woman out here that
 was much older than me. Until she had to
 go into a home. I actually had to call her two
 sons that were about my age to let them
 know that she was going to hurt herself.

Miranda: That must have been hard.

Ron: I mean, it was like a steady, very steady thing
 with her and I. And she was much, much,
 much older than me.

Miranda: How old was she?

Ron: I'll just say she was well into her seventies.
 But she was slender. She was clean. She was
 soft-spoken. She was warm. She was the
 love of my life.

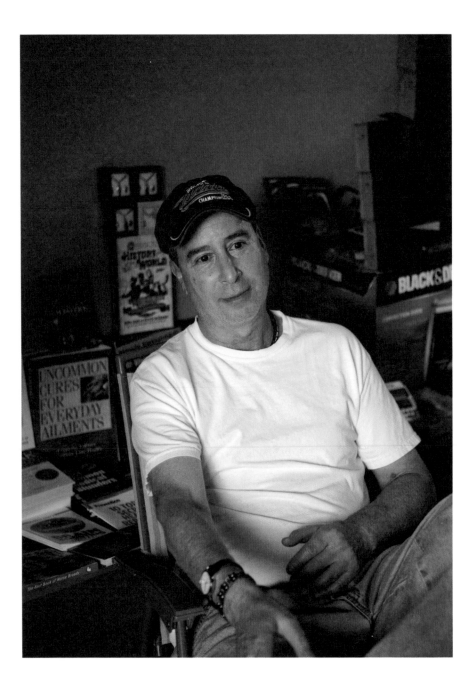

After a long time I began to understand that he would never let us leave. We just had to go. I silently counted to three and stood up. I brushed off my thighs as people do and made thank-you sounds and gestures. As we said goodbye and walked toward the door, Ron stopped me.

Ron: Miranda, quick question.

Miranda: Yeah.

Ron: Do you have family?

Miranda: Mm-hmm.

Ron: Kids?

Miranda: No kids. I just got married.

Ron: Oh, you just got married.

Miranda: Yeah.

Ron: I was going to say, somebody as adorable as you can't be single. But people always say that about me too. I've really opened up to you about who and what I am. And part of the company I have, I do marketing research. I do a lot of things where — well, I can show you better than tell you.

Miranda: We have to go, because we're —

Ron: Okay, well, I was just going to simply grab something right here and show you.

Miranda: Okay, okay.

Ron: These are Starbucks cards. There's twenty of
 them there. Do you see them?

He fanned them out like million-dollar bills, like
our minds were going to be blown by these twenty
Starbucks cards.

Miranda: Uh-huh.

Ron: I also have Exxon Mobil cards. I have more
 than twenty of them. I have wallets up there
 that are full of Wal-Mart gift cards, okay?

Miranda: Wow.

He was showing me his dowry. His nest egg.

Ron: These didn't come because I stole them.
 These took a lot of time. They took a lot of
 patience, a lot of discipline, a lot of keep-
 ing track. But with that, with that comes the
 benefit of, well —

Miranda: Well, thank you. I wish —

Ron: Thank you.

Miranda: — we didn't have another interview after
 this.

Ron: Yes. Okay.

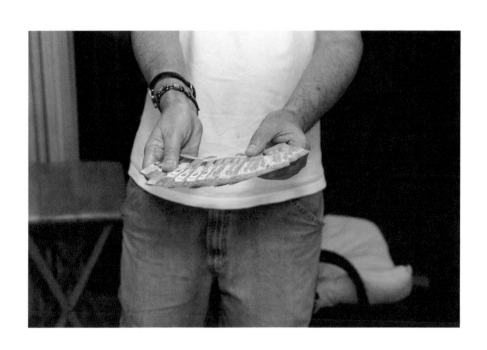

Miranda: We could stick around.

Ron: That's okay. I took so much of your time.

Miranda: Yeah, well, it was really great.

Ron: It's been a pleasure.

We silently walk-ran to the elevator and Alfred hit the down button repeatedly until the elevator doors opened. Ron couldn't help but remind me a little of Franko, my prison pen pal — or at least I was reminded of how much I gave Franko the benefit of the doubt. I focused on what was charming and tender about him and I never thought very hard about the person he killed. Who was I to judge? I was so young then that I couldn't presume murder wasn't in my future too. It seemed unlikely, but so did everything.

Twenty years later I was warier. Ron felt like a cold spot in the universe, a place that just wasn't going to warm up. There was still a small piece of me that wanted to be the only one who believed in him, the one he spared, but more than anything I wanted to grab the hand of myself at sixteen, and the hand of my future daughter, and run.

After I interviewed Ron, I had a meeting with an actor who had read my script and was considering the role of Marshall. It was Don Johnson, from *Miami Vice*. As usual, I was early, so I drove around and got lost,

which made me late, as usual. I parked on the street and then walked up to a big gate and pressed a button that alerted a video camera. I waved and then tried to say something about how he didn't need to open the gate all the way because I wasn't driving in. I held up my hands to the camera to indicate the width of my body. The gate began rolling open, I slipped through, but it kept opening. Even after I was seated inside across from Don, in his den, I could still hear the gate opening. And then it reversed direction and started the long journey home.

Don was good-looking and very solid, the way men often become in their fifties. Sometimes men with this kind of body ask you to punch them; that didn't happen this time. We talked about meditation and Buddhism. I couldn't remember if he'd had any drug problems, but I hoped he had come to meditation through recovery. It's always a relief to me when someone is in recovery; it automatically gives us something to talk about. Not that I'm in recovery, specifically, but I relate to the feeling of trying and failing and trying again. People who have been through rehab are used to talking about this — they're required to.

Don and I talked about being present and the elusiveness of "now," and then he praised the talents of his son for a while, which predictably moved me to tears. To keep from crying, I had to do the trick where you contract your butt into a tiny fist and mentally repeat the words *fuckyoufuckyoufuckyou*. We discussed the script, and I suggested he audition for the

part, which is the one thing you're never supposed to say in these meetings — apparently it's insulting, which I always forget. So the meeting was suddenly over. He walked me out, the gate opened, and it was still opening when I drove away.

I moved to Portland, Oregon, when I was twenty. Portland was the hometown of Gary Gilmore, the murderer Norman Mailer wrote about in *The Executioner's Song*. I'd read that book when I was fifteen, so I'd been thinking about Portland's dark side for a long time, but that wasn't why I'd moved there. I wanted to be part of the Northwest Riot Grrrl revolution and closer to my girlfriend. Still, if that didn't work out, I knew the underworld would be waiting for me.

I found a job in the classifieds, working for Pop-A-Lock, as a car-door unlocker. The job interview was conducted at a Denny's, and I was trained in a dump filled with wrecked cars covered with blood and hair and biohazard stickers. I wore a big red vest and a beeper on my belt. I was on call twenty-four hours a day, serving the entire tri-county region. The customers usually looked dismayed to see such an unmanly person come to their rescue, and it often took me upward of an hour to get the door open, but I always succeeded eventually ("bind and jiggle" was the trick). I sang Pop-A-Lock's praises right up until the very moment I quit, at which point I admitted it was one of the worst jobs anyone could have.

Car-door unlocking was my last real day-job, but
the truth is I wasn't entirely living off my art yet —
I was a thief. I stole not only my food and clothes, but
pretty much everything that wasn't nailed down. One
day I swiped a pair of black tennis shoes with velcro
closures from Payless ShoeSource. They looked sort of
like knockoff Reeboks. An alarm tag pierced the velcro
flap of the left shoe, which was why I'd brought a pair
of scissors with me. I cut the tag off and put the shoes
into my purse. I walked out of the store and down
the street and into a shoe-repair shop called Greiling
Brothers. I asked the man working there if he could
make these fine black velcro shoes taller; I wanted
to be tall. He asked why part of the velcro tab on the
left shoe was cut off. I studied it hard, as if seeing it
for the first time. He leaned his head back, taking in
my whole getup, and said something along the lines of
"You're an odd bird." Not exactly that, but something
that made me a bit defensive — which was my primary
emotion in those years, understandably, since I had a
lot I could be accused of, even jailed for. I responded
with something vague about being a performer and
needing the shoes for a performance. He said he'd like
to know exactly what I did, performance-wise, and so
when I picked up the now-taller shoes I brought him a
copy of my CD, *Ten Million Hours a Mile*.

This was the beginning of my friendship with
Richard Greiling of Greiling Brothers Shoe Repair.
There wasn't another brother; he just liked the sound
of it. Richard was raspy and ragged, always on the

verge of doing something ridiculously dangerous, or
saying something flatly profound. In time, I convinced
him that if he could repair every part of a shoe, then
he could probably also make shoes from scratch.
He made three pairs of wonderfully strange, blocky
shoes for me that we designed together. Eventually
he lost his shop and had to take a job selling shoes at
the department store Meier and Frank. By that time
he had starred in two of my short movies, *Getting
Stronger Every Day* and *Nest of Tens*, and was the
inspiration for the male lead, Richard Swersey, in the
feature film I was writing, *Me and You and Everyone
We Know*. I had imagined that he would play himself in
this movie, but in the end I became either cowardly or
smart and cast an actor who had a similarly raw, vola-
tile quality — John Hawkes.

I lost touch with Richard for a few years after
that. Without noticing, I mentally combined him
with John; John's career successes seemed to
imply everything had worked out for everyone. But
right around this time, as I was meeting actors and
PennySavers, I crossed paths with Richard Greiling
again. He looked the same but he said he wasn't. He
described his descent all the way to the very bottom,
which is where he said he was now. He was still just as
remarkable to me, but I could see he wasn't kidding.
The contradictions between him and the actor who
had played him made my heart ache. I re-watched
his performances in my short movies and he was
really good, probably as good as John Hawkes, just

more of a wild card. I knew I hadn't made a mistake, but it made me wonder just what kind of director I really wanted to be. LA is so many things, but it is also a company town — almost everyone I knew worked on movies, at least part of the time. Which made it hard, almost rude, to resist the rules and rituals of Hollywood filmmaking; I was grateful to be a part of it, in a way. And in another way I was desperately trying to remind myself that there was no one way to make a good movie; I could actually write anything or cast anyone. I could cast ghosts or shadows, or a pineapple, or the shadow of a pineapple.

MATILDA & DOMINGO

—

CARE BEARS
$2 - $4

—

BELL

—

I purposely hadn't read *The Future* in a long time; at the
very least, the *PennySaver* interviews were occupying
me while I defamiliarized myself with Sophie and Jason.
I liked to think of the dormant script curing like ham
in a hickory woodshed. Each day I left it alone, it got
better. And now it was time to check on the progress
it had made without me. I printed it out and put it on
my desk. I left the room and came back in, pretending
I was a snoopy housesitter; sometimes this helps make
me want to read my own work. *What have we here?* I
said to myself, peeking at the first page and then slyly
glancing over my shoulder. By page two I was me again,
but I kept going. By the last page I was in a panic. The
break had had the wrong effect. The *PennySaver* sell-
ers were so moving to me, so lifelike and realistic, that
my script — the entire fiction, including Paw Paw and
the talking moon — now seemed totally boring by com-
parison. I had no new thoughts about how to approach
Jason's scenes, and I had somehow lost the parts I

thought I'd solved. Despair was gathering. Only it didn't feel like the sentence *Despair was gathering*; it wasn't impressively dramatic like dark clouds before a thunderstorm. It was pathetic and tedious, like a person you don't want to be around.

If I'd been Sophie, my character in the movie, I would have had an affair at this point. Not out of passion, but simply to hand myself over to someone else, like a child. But even in the movie this doesn't really work out. And so I thought, as I often do, about the scene in *Indiana Jones and the Last Crusade* where Indiana is faced with what looks like thin air, a void — and he steps into it. He does it expecting he will die but knowing he has no choice. Then, impossibly, instead of falling, his foot lands on something solid. It turns out there is actually an invisible bridge across the void. It was there all along.

Indiana's predicaments are always life-or-death, so the daring move is obvious — it's the one that will make the audience scream, "Don't do it, Indiana!" My stakes were much lower. I could give up on the interviews and finish the script, or I could continue meeting strangers, believing that they would eventually lead me to the thing I needed to learn in order to finish the script. The audience probably didn't care much one way or the other; nothing would make them scream, "Don't do it, Miranda!" But I decided that Indiana would not sit down at the computer. He would ignore the voices that told him he was just a procrastinator and he would pick up the phone and call Matilda, who

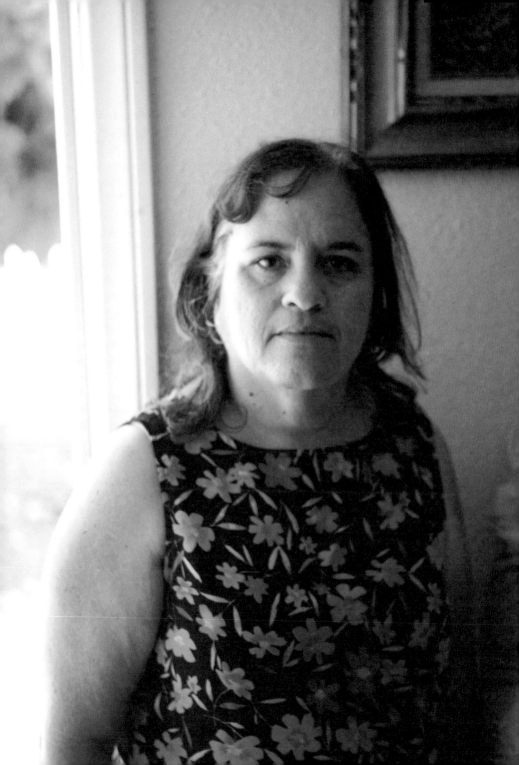

was selling Care Bears for two to four dollars each.

Matilda didn't know we were meeting at such a pivotal moment, and I didn't tell her. I just listened, as usual, and tried to feel the reality of her life, living with her husband, brother, son, and tiny puppy. She wore a pretty dress and had the confidence but not the face of a pretty woman. Her husband was regal and a bit dashing, occasionally passing through the living room with a polite nod. We sat on her couch, next to a pile of laundry, and discussed the bears.

Matilda: We collect them. I go to the swap meets, yard sales. But my special collection is over there, the Precious Moments. That's mine.

Miranda: What do you like about those ones?

Matilda: Well, maybe their eyes.

Miranda: They're kind of sad-looking. They kind of look like they're crying.

I wondered if I was projecting. But Matilda nodded in agreement.

Matilda: They're tender.

Miranda: And do you make decent money from selling them?

Matilda: Oh yeah.

Miranda: What kinds of people buy them?

Matilda: Well, most are American, Japanese...
 because Hispanics, you know — they don't
 spend money on collections.

Miranda: Where are you from originally?

Matilda: Cuba. I'm from Cuba.

Miranda: When did you move to the US?

Matilda: In December 1971. I was fourteen.

Miranda: And what's been the happiest time in your
 life so far?

Matilda: When I was living in my country.

Miranda: In Cuba?

Matilda: Yeah.

Matilda showed me around her house. The garage
had been converted into a bedroom. *Converted*
isn't really the right word — all of the furnishings of
a bedroom had been moved in, but it still had the
automatic door that rolled up, and a cement floor.
This was the master bedroom, where Matilda and her
husband slept.

Her brother and son were in the proper bed-
rooms. I poked my head into one of these rooms. An
elaborate collage of women and babies was taped
above a twin bed.

Miranda: Oh, that's a nice collage.

Matilda: That's my brother's. He's a single man, and
 he's a mess.

Miranda: So these are just like —

Matilda: He collects different kinds of actresses,
 actresses and babies. He's a single one.
 Maybe he's dreaming.

The collage was really the least of it. All over the
floor were piles of manila envelopes filled with similar
pictures and labeled PICTURES OF JAILS AND YOUNG GIRLS
AND BABYS AND PICTURES OF LAPD CARS and INSIDE PICTURES
OF LAPD SHERIFFS CARS AND NICE GIRLS AND PICTURES OF
BABIES AND ALSO PICTURES OF A PRISON.

In my lexicon of signs and symbols, obsessively
organized pictures of Prisons, Babies, and Nice Girls
are an indication that something of great conse-
quence is afoot. Someone is doing something unnec-
essary for reasons that are mysterious to everyone.
Matilda's brother, Domingo, wasn't home, and Matilda
didn't have much to say about him.

I went home and stared at the pictures of envelopes until my curiosity overwhelmed me. So I called back and made a date with Domingo for a few weeks later. He was waiting on the sidewalk when we drove up — large, gentle, and nervous. The collage on his bedroom wall had changed, but it was still in the "Nice Girls and Babies" genre. It seemed impolite to ask about the items in question before I knew anything about him, so I began with what I knew.

Miranda: Do you remember when you came over from Cuba, or were you too young?

Domingo: I don't remember nothing from over there. The only thing I do remember is living upstairs. That's all.

Miranda: How old were you?

Domingo: I was six years old. I came as my sister did also, and my aunt as well, as a Cuban refugee. We didn't come here illegally — at that time we were allowed to come from Cuba over here, free, without having to run away from Cuba or anything like that. Basically we were here and then a couple years later we became residents and then citizens.

Miranda: What's a normal day like for you?

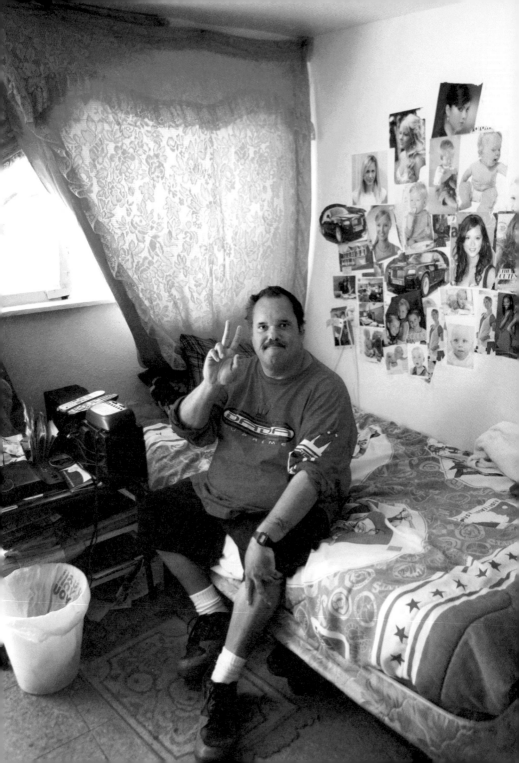

Domingo: I get up like about eight or nine in the morning. Get dressed, get a bag that I usually use, and I go to the Taco Bell that's right here on Carmenita and Telegraph. I get a free soda because I know everybody there and I'm a humble person. I have a good heart. I like to help people, so I have friends there that I met. I called the corporate offices and I told them, you know, how great they are. There's a young girl that works there — she's very nice. She's African American, but she speaks Spanish. If you go there she's going to give you a smile. I've told her and her boss, you know, I think she's great, and I'm going to keep calling the corporate office to get her promoted. There's no person that she doesn't smile around, and, you know, good morning, good afternoon, goodbye when they leave. She goes by the tables and says to everybody, "Is everything okay?"

Miranda: And how long are you there?

Domingo: Usually I'm there like an hour or two, basically. You know, they have air conditioning, so it's nice in there. And then from there I either go to the library or go to the pharmacy. At the library I go to a computer and try to find some information, some pictures. But those pictures from the

regular computers are, unfortunately, only black and white. If you want to get them in color, which sometimes I do, I have to pay a little more. But usually when my friend, the librarian, gives them to me, she does it from her computer, so she gives them to me in color. That's usually my day's routine. Oh, also sometimes I like to go to the courthouse and sit down for cases — you know, criminal cases and preliminary hearings, which are similar to trials. I observe the case from the beginning stages of the proceedings all the way until they get sentenced.

Miranda: Tell me about one of the happiest times in your life.

Domingo: Happiest time in my life was, I guess, when I became a citizen. I had to do a lot of studying for it, and I usually have problems in memorizing — like, reading comprehension I have problems with. But I was able to read it, read all the test questions and answers for the test to become a citizen. They test you — a person from the Immigration and Naturalization sits with you and they ask you questions and you have to answer them without looking. So you have to have that in your mind — you have to study before. There were a lot of

pages, a lot of pages. I had to do a lot of studying, a lot of things that I studied for they didn't really ask me about, but I did learn a lot.

Miranda: How old were you?

Domingo: That was a long time ago, in high school. But that was one of the happiest times in my life, where I did something that actually came through. I felt really happy about it, I really did.

Miranda: So tell me about these pictures on the wall.

Domingo: I have, like, fantasies and stuff, like I pretend I'm an officer, you know, a deputy sheriff, things like that.

Miranda: When did you start collecting?

Domingo: I've had quite a few years doing this. Actually, I started after I graduated from high school. I was never able to become a police officer or a deputy sheriff or anything like that. And what happened there is that I built a fantasy that I'm a judge, that I'm a police officer, that I'm a deputy sheriff, and then I investigate — I call and see what their working shifts are like. I'm going through some psychological, psychiatric treatment as well, and so I tell this to my therapist. He said, well, if it's something

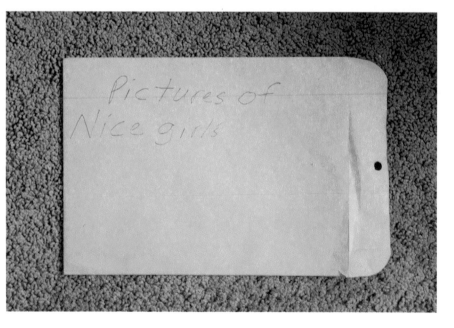

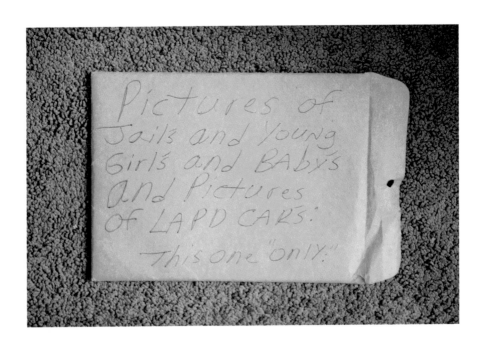

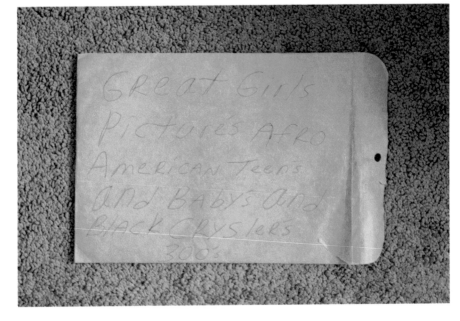

that doesn't take you away from doing
other things, it's okay to have fantasies, as
long as you don't go and tell people that
you are what you say you are in your mind.
And it is all in my mind. And then I put pic-
tures on the wall that I'm a judge, that
I have a family, that I have a car, things like
that. I have to have them on the wall for it
to come true in my head. Because if I don't
put it on the wall —

Miranda: You can't see it.

Domingo: I can't focus it in my mind. So it's got to be
something that I, um...

Miranda: You can look at a picture.

Domingo: I can look at it and I have it there itself. I
go to the librarian, my friend, and she's the
one that finds all these pictures for me. She
knows what I have them for, so she knows
that I never collect anything that's, um, you
know... naked pictures or things like that.

Miranda: It's family life.

Domingo: Yeah, with kids and things like that. You
know, I've been doing this for years, and I
usually change my pictures around when
I feel like I need to change, to be some-
body different.

Domingo walked us back to our car. We thanked
each other many times. It was unclear why we were
so thankful — it had to have been for totally different
reasons, or maybe just the shared high of commu-
nion. I found myself paying him a little bit more than
everyone else, as if this would somehow level things
out. Because of all the people I had met, Domingo was
certainly the poorest. Not the saddest, not the most
hopeless, but the person whom I felt most creep-
ily privileged around. We drove home, in my Prius.
If I interacted only with people like me, then I'd feel
normal again, un-creepy. Which didn't seem right
either. So I decided that it was okay to feel creepy, it
was appropriate, because I *was* a little creepy. But to
feel only this way would be a terrible mistake, because
there were a million other things to notice.

All I ever really want to know is how other people
are making it through life — where do they put their
body, hour by hour, and how do they cope inside of it.
Domingo was compulsive and free-floating, seemingly
unashamed, and his insides, his dreams, were taped to
the walls. That night Brigitte sent me the day's pho-
tographs; I looked through all of them, in case there
were things that I had missed by actually being there. I
studied a picture of Domingo's calendar. "Today is my
birthday," read one square. "I'm 45 years old, an old
man." I imagined that being forty-five seemed totally
implausible to him, given that he had no wife, no
babies, no job, none of the trappings of time as they
are described to all of us.

12:00 P.M.

WWW.RioHondo.Ea

√18 TodaY Alex
Paid me and
Him for my Birth
Date a Tour of
Dodger STADium
AT 8:00 A.M

√17

Today is my
24 Birthndate
I'm 2 45 years
old an old
man,

25

23

30

St. Jean Baptiste (Québec)

I clicked through all the pictures Brigitte had taken so far. What was looking for? I supposed I was looking for calendars. More pictures of calendars. And there they were. Everyone had them, and they were all hardworking calendars. They seemed weirdly compulsive for a moment, as if I'd stumbled on a group of calendar fanatics, and then I remembered that we all used to have these, until very, very recently. We all laid our intricately handwritten lives across the grid and then put it on the wall for everyone to see. For a split second I could feel the way things were, the way time itself used to feel, before computers.

Trying to see things that are invisible but nearby has always been alluring to me. It feels like a real cause, something to fight for, and yet so abstract that the fight has to be similarly subtle. When I was in my early twenties, making performances and fanzines and trying to conceive of myself as a filmmaker, I felt certain that this task was harder not simply because there were so few movies made by women, but because this felt normal, even to me. So I set out to make myself able to feel the absence of these movies made by women. I interviewed teenage girls and busy mothers and old women on the streets of Portland, stopping them and asking, "If you could make a movie, what would it be about?" I compiled their answers and portraits into a poster called "The Missing Movie Report." Some of the answers were interesting, most weren't. But was I feeling the absence now? Now that I'd called upon them, were these unmade movies changing me, like ghosts?

The results of the report were inconclusive.

It was a similarly annoying question, but I dog-
gedly asked each *PennySaver* seller if they used a
computer. They mostly didn't, and though they had a
lot to say about other things, they didn't have much to
say about this, this absence. I began to feel that I was
asking the question just to remind myself that I was in
a place where computers didn't really matter, just to
prompt my appreciation for this. As if I feared that the
scope of what I could feel and imagine was being qui-
etly limited by the world within a world, the internet.
The things outside of the web were becoming further
from me, and everything inside it seemed piercingly
relevant. The blogs of strangers had to be read daily,
and people nearby who had no web presence were
becoming almost cartoonlike, as if they were missing a
dimension.

I don't mean that I really thought this, out loud; it
was just happening, like time, like geography. The web
seemed so inherently endless that it didn't occur to
me what wasn't there. My appetite for pictures and
videos and news and music was so gigantic now that if
something was shrinking, something immeasurable, how
would I notice? It's not that my life before the internet
was so wildly diverse — but there was only one world
and it really did have every single thing in it. Domingo's
blog was one of the best I've ever read, but I had to
drive to him to get it, he had to tell it to me with his
whole self, and there was no easy way to search for
him. He could be found only accidentally.

Scientifically, my interviews were pretty feeble, as questionable as "The Missing Movie Report," but one day soon there would be no more computerless people in Los Angeles and this exercise wouldn't be possible. Most of life is offline, and I think it always will be; eating and aching and sleeping and loving happen in the body. But it's not impossible to imagine losing my appetite for those things; they aren't always easy, and they take so much time. In twenty years I'd be interviewing air and water and heat just to remember they mattered.

DINA

–

CONAIR HAIR DRYER
$5

–

SUN VALLEY

–

Sun Valley was familiar to me; earlier that year I'd
worked with a fabricator based there who helped me
make a series of sculptures. I had driven through the
area a couple times a week, but always with my mind
on myself and always in a hurry — the car is so hard to
stop once it gets going. Now I noticed that lots of other
things were manufactured in Sun Valley too, giant props
for movies and enormous metal beams. Big things were
also destroyed and recycled here, like cars and appli-
ances. And as I walked toward Dina's house I suddenly
became aware of the largest of all the large things, the
Verdugo Mountains. Sun Valley lived in their shadow. I
wondered how I'd missed those all the other times I'd
driven through here, and I felt like I was probably a bet-
ter person now — a woman who wasn't interested only
in her own internal landscape. I might never finish the
script, and the world would be none the worse for that.
Most likely I would go into one of the helping profes-
sions, maybe become a secular, married nun.

We clattered into a fenced-in lot filled with rows of movable-looking houses forming carless streets. The community had a tidy FEMA quality to it. It wasn't depressing, but only because it was so new; like new Tupperware, it would become old immediately. Dina and her daughter Lenette had just moved in and were thrilled to be there. It was a brand-new life and a good time to get rid of things.

Miranda: So it works?

Dina: Oh, it works. It works.

Miranda: And how long have you had this hair dryer?

Dina: Oh, the hair dryer I've had for a long time, a long time. Since junior high or high school at least, so that's been many years. But it has issues.

Miranda: You have it here?

Dina: Yeah, I do have it.

Miranda: Could you get it?

Dina: Want me to get it now? Okay. It's not bad for being that old.

Dina left and came back with a very old hair dryer.

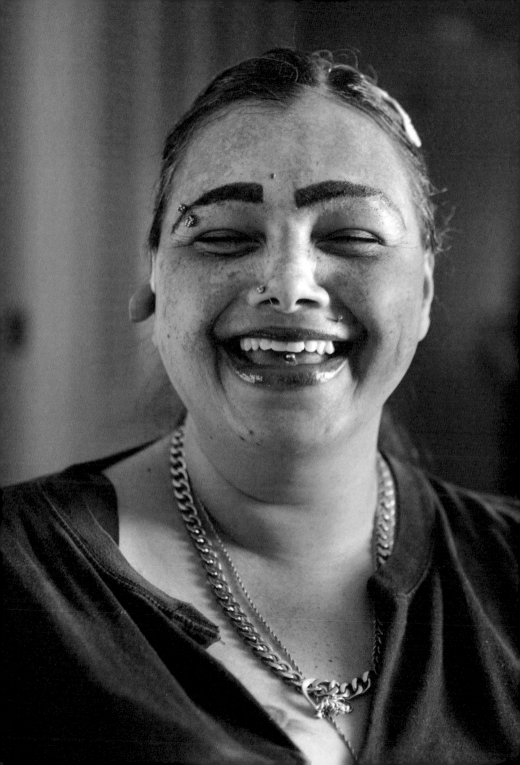

Miranda: Yeah, that is actually not a modern dryer.

Dina: No, it's not, but still — it's got the cold but-
ton, the cool button.

Miranda: So you got it in junior high or high school —
do you actually remember getting it?

Dina: I remember using it. I think my mom bought
it. Yeah, I remember using it. We used to do
hairspray.

Miranda: Do you have pictures from back then?

Dina: No.

I wanted to see how she had become the mys-
terious woman she was. Her large, freckled body was
decorated with tattoos and piercings, and her painted
eyebrows only loosely referenced real eyebrows —
they were the color of wine. She wore a hot-pink
cell-phone earpiece like it was jewelry, and a picture
of Popeye scowled on her T-shirt. I didn't know if she
was older or younger than me, or maybe she was a
new age, one that didn't involve numbers.

Dina: You know what — wait a minute. I do have a
scrapbook. I can show it to you.

Miranda: That'd be great. I'd love that.

She opened a closet and bumped around in there for a while, talking out loud to the scrapbook, asking it where it was at. Finally it revealed itself and she carried it over, shaking her head.

Dina: This scrapbook is looking bad, huh?

Miranda: It's the real thing.

Dina: Yeah, this is the original. Look at that! Look at that! Very creative — I took them out of the magazines.

Teenage Dina had glued magazine pictures of black women into the scrapbook — they were her pretend sisters. It seemed everyone I met had an imaginary paper family. Dina smoothed the face of the model and deciphered her own bubble handwriting.

Dina: "Wish, wish, wish upon a star for sisters." Isn't that something else? But if I remember correctly, the best sister is on the next page. I even named them.

Miranda: Right. So this is Sharon and that's Linda. "I want my best, truly sister. I really mean she is always my sister. She loves me too."

Dina: That's pretty deep.

As Dina talked about her family I studied the living room. It didn't have the layers of living that I was used to drawing my questions from. Most of the furniture looked as temporary as the house, designed for dorm rooms.

Miranda: How's the inflatable couch?

Dina: That's awesome. We haven't put it to the test yet, but that thing can hold... it's a queen size. It's five-in-one, actually.

Miranda: It turns into a bed.

Dina: Yeah. It's five-in-one.

Miranda: So a couch, a bed... that's two.

Dina: I forget.

Miranda: Maybe it floats, so it's a boat — that's three.

Dina: It does look like one, huh? And you know the good thing — it can hold up to six hundred pounds. Seriously, it can hold a lot of weight, so that's good. I like different things, you know what I mean? I like that.

Finally I realized Dina herself was the most intricate, storied thing in the house. Her size might have been intimidating, but her decorations were a clear invitation.

Miranda: Tell me about your amazing face — your piercings and stuff. When did you get into that?

Dina: I just like decorating the body, even though we shouldn't — okay, we know that. The thing is, I love decoration. I like art. So why not?

Miranda: Can you do anything special with your tongue piercing?

Dina: Yeah, you can. You're gonna take me there?

Miranda: I'm curious.

Dina: I don't know if I should say this.

Miranda: You totally can.

Dina: Actually, when I got older, I started getting curious, so I — I'm blushing now. I'm gonna say it. Oral sex, yes. This will put a really good spice to it. I called the shop way before I got this done, and they actually had vibrating ones.

Miranda: No way.

Dina: Yes way. So I was like, "Wait a minute! That sounds awesome for me, in my book!"

Miranda: So has that been put to the test?

Dina: It's too soon.

Miranda: Because it's still healing?

Dina: Yeah, still healing. I'm waiting for that.

Miranda: And do you have a partner?

Dina: Well, not really, but their dad, you know. He's an iffy-sometimes person, but yeah. He would be a candidate.

Miranda: And what is this tattoo?

Dina: Oh, that's the kids' father. I didn't do my homework and I didn't know how much it would cost to laser off his name. So what did I do? I put "RIP" underneath it — "Rest in Peace." He kept hearing I took it off, and then when I saw him again, I showed him. That surprised him. I said, "Well, at least I didn't put 'RIH'" — like "Rest in Hell," you know what I'm saying?

Miranda: Oh, right — that's true. You said "Rest in Peace."

Dina: I was just trying to tell him, you know, break it down. Because when you're done, you're done. You may go back to the people, whatever, but you're done. I wanna get one that says, "Respect the Queen," on my back, by my skirt line. That's next.

I asked Dina to give me a tour. It was a short one. We poked into the bedroom of Dina's daughter Lenette; she was texting while watching TV, but after her mother cajoled her, she agreed to come out into the living room and sing a Miley Cyrus song for us. It was called "The Climb." Lenette sang it with a wide mouth, waving arms, and hands that clutched the air.

I can almost see it,
That dream I'm dreaming, but
There's a voice inside my head sayin'
You'll never reach it.
Every step I'm taking,
Every move I make feels
Lost with no direction.
My faith is shaking but I
Got to keep trying,
Got to keep my head held high.

There's always going to be another mountain.
I'm always going to want to make it move.
Always going to be an uphill battle,
Sometimes you're going to have to lose.
Ain't about how fast I get there,
Ain't about what's waiting on the other side,
It's the climb.

Keep on moving.
Keep climbing.
Keep the faith, baby.

It's all about
It's all about
The climb.
Keep the faith.
Keep your faith.

I felt like Miley Cyrus was speaking directly to me through Lenette, and she was being very clear — she wanted me to keep the faith. I read Dina's Popeye T-shirt, I YAM WHAT I YAM, and I felt that I too was what I was. I was a writer, and my characters, Sophie and Jason, were right here with me. In fact, they *were* me, both of them. Was it possible that Jason read the *PennySaver*? I knew for a fact that he did, because the movie was set in LA and everyone in LA, real or fictional, gets the *PennySaver* with their mail. It was so obvious, there all along, the invisible bridge — Jason wasn't selling trees, he was buying things through the classifieds. He was meeting strangers, just the way I was, and it was transforming him and uniting him with humanity. He would stand in a living room just like this living room, and listen to someone like Lenette sing. We probably wouldn't be able to afford the rights to the Miley Cyrus song, but who knew? Now was no time to think small. I tried to imagine who would play Dina. Or Ron. Or... Domingo. The thought was offensive. No, clearly these people would have to play themselves. We thanked Dina and I said goodbye, knowing that it wasn't really goodbye. I wanted to wink at her or give her some kind of

indication that she would soon be starring in a major motion picture, but I restrained myself.

It was like the scene in *Pollock* where Marcia Gay Harden looks at Ed Harris's first splatter painting and says, soberly, "You've cracked it wide open, Pollock," and you know she's right because those splatter paintings are worth a kabillion dollars in real life now. Marcia Gay Harden wasn't with me as I drove home from Sun Valley, so I had to say it, soberly, to myself — *You've cracked it wide open, July* — and then I had to look exhausted and unaware of the greatness I'd stumbled into, the way Ed Harris does, and then I had to be the woman watching the movie based on my life, someone who might have been born today but who thirty-five years from now would know that history had proved the brilliance of Jason buying things through the *PennySaver*. She shivered a little, this woman who would be thirty-five in thirty-five years; tears jumped to her eyes as she watched the reenactment of this pivotal moment in film history. It didn't even matter that she wasn't a fan of my work — I'm not a huge Pollock fan. It's just the way Marcia says it. I whispered it again: *You've cracked it wide open, Pollock.*

I'd had a similarly groundbreaking revelation twenty-five years earlier, when I was nine. The epiphany came one night, just before I fell asleep: I would make an entire city out of cereal boxes. I'd collect the boxes over months and I'd paint them, hundreds of them, stores and streets and houses and freeways, forming a whole little world that would be an accurate

representation of my hometown, Berkeley (although
I wasn't totally married to the specifics yet — it might
be better to make it more of an Everytown, USA, since
geography wasn't my strong suit). The city would take
up the whole basement floor and I would bring spe-
cial people down there, to the basement, and turn on
the lights and, boom, their minds would be blown to
pieces. After passionately nursing this idea for about
an hour, I suddenly had another idea: No I wouldn't.
Of course I wouldn't make an entire city out of cereal
boxes in the basement. The moment I had this sec-
ond thought, I knew this was the real one. But I also
felt certain that the thought itself was the only thing
that had stopped me, like a witch's curse — or, no, like
the witch *hunters*, the small-minded, fearful Local
Authorities.

From then on to this very moment, I had done
everything I could to avoid them, but after almost
three superstitious decades I'd come to realize that
the Local Authorities are always there, inside and
outside, and they get most riled up when I begin to
change. Each time I feel something new, the Local
Authorities step in and gently encourage me to burn
myself alive.

So now I called Dina immediately, before the
second thought could come. She took the idea of an
audition in stride, as if it were the usual outcome of
trying to sell your hair dryer. The next day I drove back
to the FEMA-like encampment with Alfred and a video
camera and suggested that we begin by reenacting our

meeting the day before. I would knock on the door, she would let me in, she would tell me about the hair dryer. Get it? Yep. Okay, let's try it.

An unexpected thing happened when Dina opened the door, and it wasn't the unexpectedly wonderful thing I was expecting. She stopped using any contractions or colloquialisms — *isn't* became *is not*, *yeah* became *yes*. Her arms suddenly moved like a museum docent's or a stewardess's, gesturing formally this way and that. Every living thing had mysteriously died the second we turned the camera on. I tried in vain to start over, to loosen the air, but after a while I felt out of line, almost rude. Eventually I let go of my plan and asked if Lenette might sing for us again. Lenette performed a rap she had written herself, titled "La La." It was very, very catchy. I had it in my head for days. But Dina and Lenette would not be in the movie, and this was a very bad idea, casting people through the *PennySaver*. Whoever was responsible for such a bad idea should be burned at the stake.

JOE

–

FIFTY CHRISTMAS-CARD FRONTS
$1

–

LOS ANGELES

–

And so I went to Joe's, knowing that he would be the last person I interviewed. The PennySaver mission had been a worthy escape, but it felt different now that I had tried to make it useful and failed so completely. It was a little bit silly and definitely frivolous, given how little time I had left in every sense. I'd gone from high-high to low-low, and now I was just trying not to disappoint the man selling the fronts of Christmas cards.

Joe lived near the Burbank airport; a plane roared over my head as I rang the doorbell.

Joe: What's this, a machine gun?

Miranda: That's a camera. And just to get it out of the way, here's your payment for the interview.

Joe: Yeah, we could really use it, I'll tell you. We're living on about nine hundred dollars a month from Social Security, so it's kind of tight, the money is, and as you get older you

need more pills and more medical care. I never went to a doctor the first fifty years I was born, but after then you're falling apart. I just turned eighty-one about three weeks ago.

Miranda: How long have you lived here?

Joe: It'll be thirty-nine years in August that we've been here. Moved here in 1970.

Miranda: Where are you from originally?

Joe: Chicago.

The house was very clean and worn; each piece of furniture was tidily being used to its very end. The walls were covered with a lifetime's worth of pet photos, cat and dogs, but there were no actual pets in the house. Out of the corner of my eye I could see shelves filled with what looked like handmade cards.

Miranda: And what was your work?

Joe: Well, I was a painter, a painting job, and I turned into a contractor when I came out here, and I was doing real good.

Miranda: So a painter of, like, houses?

Joe: Houses, yeah.

Miranda: What are all these cards? Did you make these?

Joe: Yeah, I make cards for my wife. See, what I
 do is I make them out of paper like this, and
 I cut these pictures out of magazines and
 papers. Then I make the poem here, then I
 make limericks. But I don't know if you want
 to read some of them — they're pretty dirty.

Miranda: Oh, really? Can you read me one?

Joe: All right, if you want. Let me find a good one.

 There once was this beauty from the city
 And her boobs were so big it was a pity
 Her boyfriend marveled about her nice chest
 Then he proceeded to lunge for her breast
 Soon his mouth was jammed with her left titty.

Miranda: Very nice rhymes.

Joe: The first and second and fifth lines gotta
 rhyme, and then the third and fourth lines
 rhyme. Say for instance the word *sex*. Well,
 there's only maybe two words that it can
 rhyme with, so I have to go through and dig
 back in the library.

Miranda: And does she like them? What's her
 reaction?

Joe: Oh, yeah, she likes them. A couple of years
 ago she started wanting to make one for me,
 so she's got a couple of little ones up there
 like these. I make her nine cards a year.

Mother's Day and our anniversary, and the fourth of July is the day I met her, in 1948, so that's the last card I just made. And I make Christmas and New Year's, and Easter, and Valentine's Day. We just celebrated our sixty-second anniversary — we've been married sixty-two years.

Miranda: I just got married about two months ago... I hope we have as many fourth of Julys together.

I did some quick math — in sixty-two years I would be ninety-seven and my husband would be one hundred and five. Our limericks probably wouldn't rhyme anymore. I turned my attention to a huge collage of pet photos.

Joe: All them animals are gone now, but those are from years ago. The last dogs died in 1982. We had nine of them, and they all died within fifty-one days. Could you believe it? From Christmas Day till the first of February.

Miranda: You had nine dogs at once?

Joe: Yeah, we had twelve dogs when we moved out here, and for the first six, seven years people thought we only had one dog because they were more or less in the house

all the time. Now we've got cats, but one, Mother wants to take him in tomorrow, I think, and maybe put him away. He's maybe nineteen years old, and all of a sudden he started going downhill. We feed him about eight times a day, but yet he's skin and bones now. The vet says that happens some-times when they get older, because I know he eats. But he's pretty bad now.

Miranda: What's his name?

Joe: His name is Snowball, and his picture should be up here someplace. It's over in those pic-tures over there — he's a white cat. And the other one's in the bedroom with my wife; her name is Silky.

Miranda: What's in that container hanging from the ceiling?

Joe: Oh, that's the favorite toys of some of our pets. See, it says, THE NAMES ON THIS CONTAINER ARE OF THE EIGHT PUPPIES THAT I BROUGHT TO CAL-IFORNIA IN AUGUST 1970. ROSIE OUR OUTSIDE CAT FOR SEVENTEEN YEARS, JANNIE, GINGER, BONNIE, HUGGY BUMBUM, BIG FAT TEDDY BEAR, RANDY DANDY DO ZO, PRINCESS TOOTSIE BELL, MISSAPUSSY, CLYDIE BOOPS, BLACKIE BIG BOY, CORKY... and so on.

Joe looked misty-eyed as he read the names on the bucket; a rare moment of silence came over

him and he glanced around the room as if looking for something else to say. I pointed at a pile of lists.

Miranda: Are these grocery lists?

Joe: Yeah, I shop for seven different widows and one widower — they can't get out of the house. I've got one jacket that I wear when I go to the store. It belonged to a policeman I knew that got shot and killed, and his brother gave me his jacket. He says, "Every time you go to the grocery store I want you to wear it." Well, I go at least four times a week, at least maybe two hundred times a year, times thirty-five, thirty-six years. I must've worn that to the store, oh, three or four thousand times, and my wife has had to repair it. But now it's almost beyond repair.

Joe wanted to show me the backyard, which was filled with dozens of poky palms that he said were all descended from one tree that he had pulled out of someone's trash. We wove between the plants to the back wall, which was engraved with names.

Joe: This is where I got most of the dogs and cats buried. I don't bury them six inches under the ground — I dig a hole seven foot deep, figuring no one will ever take them out, and I keep them close to the wall. I figure if

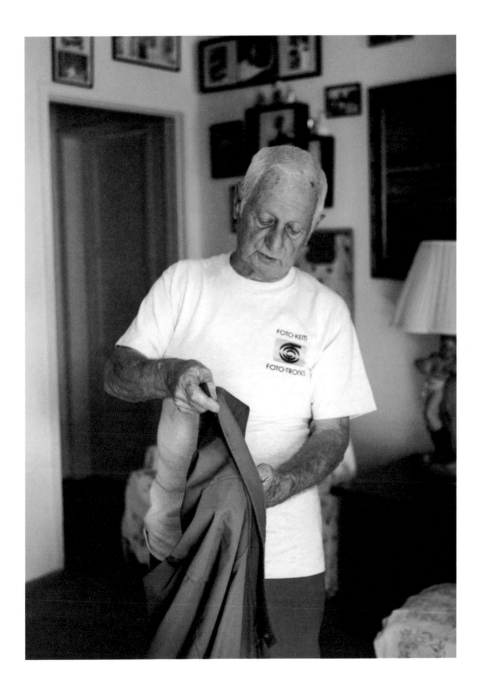

anybody comes in there and puts in a pool, they wouldn't affect it at all.

Miranda: That's pretty deep.

Joe: Yeah, I have to have a ladder right next to the hole so I can get out. I can't even get out of the hole.

Miranda: What's written in the walls?

Joe: Well, I chiseled the dogs' and cats' names there with a chisel and a hammer. There's names all over — there's Jilly and Corky and Mittens and Puggy and all.

Miranda: And the hole, is that for a cat that is —

Joe: That's Snowball's — gonna have to be put down.

Miranda: Right. So that's in advance.

Joe was overwhelming, but not like Ron. He was like an obsessive-compulsive angel, working furiously on the side of good. It became harder and harder to remember that I had met him just today and had no responsibility to him, or history with him.

Joe: Maybe this Christmas you can come over, because I put my decorations up about the fifteenth of November and leave them up till the fifteenth of January. So you're welcome

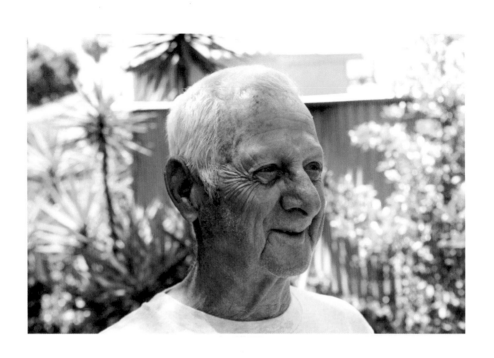

to come anytime. What'd you say your first name is — Mary?

Miranda: Miranda.

Joe: Oh, Miranda.

Miranda: What was your name again?

Joe: Joe.

Miranda: Joe. Right. Well, we don't want to take up any more of your time. We'll just get —

Joe: That's okay, I got time.

When we finally extricated ourselves, we just sat in the car, very quietly, and were oddly tearful. Alfred said something about wanting to be a better boyfriend to his girlfriend. I felt like I wasn't living thoroughly enough — I was distracted in ways I wouldn't be if I'd been born in 1929.

And yet the visit was suffused with death. Real death: the graves of all those cats and dogs, the widows he shopped for, and his own death, which he referred to more than once — but matter-of-factly, like it was a deadline that he was trying to get a lot of things done before. I sensed he'd been making his way through his to-do list for eighty-one years, and he was always behind, and this made everything urgent and bright, even now, especially now. How strange to cross paths with someone for the first time right before they were gone.

I called Joe again later that day — I didn't let myself think very hard about it. I picked up Alfred and the video camera and drove back to the house by the airport. I suggested we reenact our first meeting; I would knock on the door, he would let me in, he would show me the Christmas-card fronts. Get it? Yep. Okay, let's try it.

An unexpected thing happened when Joe opened the door, and it wasn't the unexpected thing I now knew to expect. Joe ad-libbed. He told me to watch my step when I came in. He didn't go straight for the cards — he showed me around a little. He pointed out some things he'd wanted to show me anyway. He hadn't forgotten about the reenactment — he just had his own agenda. I had to interrupt: "Now I'm going to try to leave, and remember how you sort of wouldn't let me leave last time?" He nodded. "Do that, don't let me leave." I headed for the door. "Stick around," Joe called out. "I might show you some things you never knew existed."

We went to the backyard to reenact Joe's tour of his pet cemetery. "Our cat is named Paw Paw," I said, thinking Jason could say something like this. Joe looked at me with confusion and I explained there was a cat named Paw Paw in the movie. "Was he named after the lake?" he asked. "No," I said, and I tried to explain that he wasn't completely real, even in the movie; he was more a symbol of this couple's love. He interrupted me. "Because me and my wife met at Lake Paw Paw, sixty-two years ago."

I drove home with a tape full of scenes that started out as improvisations but consistently careened into reality, becoming little documentaries. Joe could do what I asked, but his own life was so insistent, and so bizarrely relevant, that it overwhelmed every fiction. And I let it.

I thought about his sixty-two years of sweet, filthy cards and something unspooled in my chest. Maybe I had miscalculated what was left of my life. Maybe it wasn't loose change. Or, actually, the whole thing was loose change, from start to finish — many, many little moments, each holiday, each Valentine, each year unbearably repetitive and yet somehow always new. You could never buy anything with it, you could never cash it in for something more valuable or more whole. It was just all these days, held together only by the fragile memory of one person — or, if you were lucky, two. And because of this, this lack of inherent meaning or value, it was stunning. Like the most intricate, radical piece of art, the kind of art I was always trying to make. It dared to mean nothing and so demanded everything of you.

I imagined Jason meeting Joe and experiencing the light-headed feeling that I was having. I knew I would fail at it, this reenactment; I would make something a little clumsier and less interesting than real life. But it wasn't the Local Authorities telling me this; it came from higher up, or deeper down, and it came with a smile — a challenging, punky little smile, a dare. I smiled back.

SHOOTING

–

THE FUTURE

–

LOS ANGELES

–

Jason: I'm gonna let it choose me. I just
 have to be alert and listen.

Sophie: But what if it doesn't—

Jason: Shhh. I'm listening.

If Sophie was all my doubts and the nightmare of who
I would be if I succumbed to them, then Jason could
be the curiosity and faith that repel that fear. I went
back to the beginning of the script and added this
impulsive, superstitious streak of Jason's — he would
meet only Joe, not all the other *PennySaver* sellers,
but he would go about his expedition the way I had,
on a whim, trying to believe that each thing meant
something, and so eventually learning what he needed
to know. It took me a little while to resign myself to
the fact that Dina, Matilda, Ron, Andrew, Michael,
Pam, Beverly, Primila, Pauline, Raymond, and Domingo
would not all somehow be part of the movie, but then

how could a fiction contain them all? I was now acutely aware of how small the world I'd written was; it had to be my bonnet-sized, tightly clutched version of LA. I knew that if I really wanted to introduce the people I had met, I would one day have to attempt some sort of nonfictional document. (That day has come.)

I wrote a series of simple scenes between Joe and Jason that re-created my experience with him. After Jason and Sophie become fixated on their own mortality, Jason decides to use what little time he has left being guided by fate — first through a seemingly meaningless self-assigned tree-selling job, and then by answering an ad in the *PennySaver*. I wrote three scenes for Joe.

(1) Joe sells Jason an ancient hair dryer (inspired by Dina), and in an unsettling way urges him to come back when he's ready.

(2) When Jason comes back, Joe shows him the cards he makes for his wife and reads a dirty limerick. He then recalls the terrible things that can occur in the beginning of a relationship. "We didn't have any problems like that in the beginning," Jason would say. "You're still *in* the beginning," Joe would respond.

(3) Jason visits Joe one more time, and this time he notices Joe has three little hippo figurines that Sophie and Jason also have. And the couch — they have the same orange couch. And they both have the same M.C. Escher drawing of a never-ending staircase. I wanted to use the real-life Paw Paw coincidence, but it seemed too meaningful; these visual details were

light enough to slip by, hopefully, and the Escher was
my own joke with myself about what I was trying to
do — to be almost kitschily surreal and yet also really
mean it. Before Jason leaves, Joe gives him a toy for
Paw Paw, a ball on a spring that swings back and forth
like a metronome.

These three scenes were 80 percent improvisa-
tion and 20 percent scripted; Joe was allowed to
mostly just talk on a theme, but he had to say a few
specific sentences, which I would read to him off-
camera and he would repeat. He would wear his own
clothes and we would shoot in his house.

It was this quasi-theoretical ninety-third draft of
the script that became fully financed, greenlit, in the
winter of 2009. I always pictured a fat man flipping a
switch by his desk to turn on a green light. It's easy
— you just have to convince him to lift his pudgy little
finger. In this instance there was no man, no decisive
switch, just a lot of calculations, mostly subtractions,
emailed between like-minded companies in Germany,
the UK, and France. The bulk of the money would
come from Germany, with the stipulation that we hire
a German crew, get them all visas and places to live
in LA, fly them to America, shoot in twenty-one days,
and then fly them back home. Also, a certain percent-
age of the cast would have to be European, with proof
of citizenship — meaning that most minor characters
would have accents. And finally, I would have to live
in Germany while I completed post-production there
in the winter. Great, I said, and meant it, knowing that

this was the cost of casting actors who weren't huge stars (including myself) and one actor who was actually a retired housepainter. It seemed like a reasonable price to pay for getting to tell such a strange story in the most expensive but ultimately most accessible of mediums. *Dankeschön*, I said. Let's go.

Now that I was counting on him, Joe's entire existence suddenly seemed pretty precarious. Needless to say, he didn't have email or a cell phone. I gave his number to my producer, but Joe never seemed to answer. Eventually Alfred drove over to his house and discovered their phone had stopped working and they hadn't gotten around to fixing it. Alfred bought him a new phone, and I bought a La-Z-Boy chair for Joe's wife, Carolyn; she had diabetes and the doctor said she needed to elevate her legs. I almost never saw Carolyn — she was a mythical muse to me, the subject of hundreds of poems. I'd read about her titties and even her twat, but she was always in the bedroom with the door closed.

I kept Joe out of a lot of the preparation leading up to shooting. I didn't really rehearse with him like I did with Hamish Linklater (Jason) and David Warshofsky (Marshall). I didn't even show him the script, actually. My feeling was that Joe was pretty much going to be Joe on the shoot day, and there was nothing I could do to change that — which was why it might work. I didn't ask him to participate in the screenplay reading I did a couple months before the shoot; it would be long and agonizing and might give

him some bad ideas about what acting was. An actor named Tom Bower read the lines I'd sketched out for Joe. I asked Tom to also read the lines for the Moon; some roles hadn't been cast yet, so a few of the actors had to play more than one part at the reading. We all muddled through it, and afterward I met with a friend to get her notes. They were many, but she did think I'd made some good changes, especially my idea for Joe to also be the Moon. Which he was, from that moment on.

I'd rather not describe the first week of shooting. When I am anxious I lose weight, and I lost seven pounds that first week. Everything that could go wrong did. Except, and I pointed this out at the end of each day: no one had died.

Then, at the end of the week, my producer, Gina, said she needed to tell me something; it was about Joe. My heart sank. He was okay, but when the location scout was looking at his house, Joe mentioned he'd just gotten a diagnosis of cancer from the doctor and he had only two weeks to live. We were shooting his scene in a week. Gina said she'd talked to him and he insisted he really wanted to do it, but that it was up to me. All our movie problems went away for a moment, and there was just sorrow, a terrible ache for this man and his wife. And I knew there was no way we could go forward with him; it was irresponsible and frankly just scary.

So that was that. I called Joe from the set. He said
he felt fine, and I said I knew he did but that I just had
to do what I thought was best. "Well, you're the boss,"
he said glumly. I had been used to his chatty bluster,
but in that moment I heard the man who had painted
buildings for seventy years, a hard worker who was
used to being part of a team and doing what the boss
said. Some bosses had probably not been very nice.

That weekend I sat in a room and watched elderly
actors read Joe's lines. I was so exhausted that my
personal goal was just not to cry during these audi-
tions. The whole idea for the role of Joe was Joe.
Most of the lines I'd written didn't matter; they were
just placeholders for where Joe would improvise.
When these old men improvised, they drew upon their
personal histories — as lifelong actors. They weren't
a boring group of people, but none of them had met
their wives at Lake Paw Paw.

After watching one particularly frail man hobble
through his reading, I complained to Gina that these
eighty-year-old men actually seemed sicker than Joe;
who was to say that all of them didn't also have cancer
and just two weeks to live? It also occurred to me now
that Joe had been counting on the checks we were
about to give him, for his work and for the rental of his
house. Had I come into his life, gotten his hopes up,
and then let him down — left him to die?

After the bleak auditions, I asked my husband
to come with me to meet Joe; I didn't trust myself
entirely. The two of us paced around Joe's living room,

trying to paint a picture of what a movie shoot was like. "A normal day is really long," I said. "Like twelve or fourteen hours." "There would be lots of people in here," my husband said, looking around the tiny house. "It would be like the army coming in and taking over." "Will they mess up the carpets?" Joe asked. "No, no," we said, "they'd put rubber mats down, all over the house." After a while we'd talked over every last detail and there was just nothing more to say. I had to call it. "Well," I said shakily, "I'd like to do this with you, if you really want to." "I really do," Joe said.

We splurged and ran two cameras all day, knowing we couldn't expect Joe to repeat things he'd done, so each scene was filmed tight and wider at the same time. Then we'd shoot Hamish's various reactions, which would hopefully bind the dialogue into the fiction. When I asked Joe to sell Hamish the old hair dryer, he handled it like a seasoned improviser, hilarious and real. Much harder was trying to get him to say specific lines, especially "You're still *in* the beginning." It was blisteringly hot, the room was crowded, and he'd been working for hours and hours (many of them spent waiting for planes to fly by). It was so hard to keep insisting that he say this particular sentence that had long since lost all meaning. He must have tried fifty times, so sweetly, always missing by a mile and then launching into a monologue about his own early married years, which he remembered perfectly. Finally on one take he said, "You're in the *middle* of the beginning, right now." It was a much better and

more specific idea — that a beginning could have a beginning, middle, and end.

At the end of his fourteen-hour shoot day, Joe was in good spirits and seemed reluctant to see us all go, especially the pretty women. And two weeks later, he was still very much alive, making repairs on his house. When I was done shooting, I hurried to edit his scenes and record his voice-over lines as the Moon. But Joe continued to not die, and so after a while I relaxed, and as I shaped and reshaped the movie he indulged me with many, many recording sessions. One time I brought my laptop so I could watch the scene before we began the call-and-response process of recording. He seemed disconcerted at the sight of himself on the screen. "Strange to see yourself on there, isn't it?" I said, turning the screen away from him. "I didn't realize I was so old," he said.

At the end of our last recording session, I asked him how he would describe what had happened, what we had done together.

Joe: Well, about six years ago I bought fifty thousand Christmas cards from a friend of mine when he got a heart attack. So I put the ad in the *PennySaver* for the cards, and you came up and knocked on the door and told me you were answering the ad. And then

later you explained to me what you wanted to do and asked if I'd be willing to do it.

Miranda: Why'd you do it?

Joe: Well, I'm kind of adventurous. I thought it would be worth a try and see how I liked it as I went along.

Miranda: And how was it?

Joe: You were real good to work with. You want something done and you'll stop and think about exactly which way you want it and you'll do it quick. I don't know if there'd be a future in it for me, you know, making a little bit on the side. But I know I'm not going to be a big movie star.

Miranda: How was the day when we shot at your house?

Joe: Well, it was a little hectic, but I'd get up early in the morning to feed the cats at about five thirty or six. These are all the neighbor's cats, not mine. Mine are all dead now. I went over to a parking lot where most of the help parked, and they served breakfast. Well, I got a couple cups of coffee and a couple of doughnuts and that. Then I came back here. But then it started becoming a little hectic because they had a lot of people standing around not doing anything and I didn't know

what their purpose was. I had to tell them to keep out of the one bedroom because I got a lot of important papers in there, you know, and I didn't want them mixed up. But other than that, everything was pretty good.

Miranda: How was it working with Hamish?

Joe: Hamish was real congenial — I got along with him from the time he got here to the time he left. I was kind of surprised, you know, a big star like that coming in for a little thing like this. But I figure maybe this is going to be a big hit, you know. Going to win an Academy Award.

Miranda: When was the last time you went to the movies?

Joe: We don't go to the shows very often, since prices started going up, you know. The last time I went to a movie was in October 1969. It was an X-rated movie, when they first started coming out in the late '60s. It was at an outdoor theater — I don't remember the name of it offhand. But on all the streets around, all the cars were parked with hundreds of kids standing on the roof watching the movie. You know, getting to see it free. Learning something new like they'd never done it before.

I finished the movie in Germany and flew home the day before Thanksgiving. The day after Thanksgiving I called Joe. His wife Carolyn answered and said Joe had died two days earlier.

I was so sorry, and I kept saying that, and though we hardly knew each other, we kept laughing and crying. I had thought of her as shadowy or slight, but she wasn't at all. Carolyn was open and ardent, with a gravely voice. We made jokes about Joe, and in laughing we forgot for an instant and then remembered and cried again. And all the while I was trying to get off the phone because it seemed so presumptuous to talk to her right now. Who was I? Just some person who'd answered her husband's ad in the *PennySaver*. But she wanted to tell me about his last day. "He was in bed, and I kissed him, and, you know, diddled him a little, and then I went out of the room for a moment, and when I came back he was gone." I made sympathetic noises, but I was thinking, Diddled? Was Joe masturbated before he died? I thought about the dirty cards and it seemed possible. Carolyn described some "wonderful Jewish people from the Skirball" who came to wash his body and take care of everything. She wept and said that this wasn't the plan; she was supposed to die first.

Brigitte and I visited her a couple weeks later. It was strange to be in the house without Joe, very quiet. And of course Carolyn wasn't in her bedroom as usual. "Do you want to see him? He's right over there," she said, pointing behind me. I smiled with

uncomprehending horror and turned around very slowly. "In the paint can. Because all he did was paint. And he never stood still. We put him in the can so he's here, where I can see him. He's not out somewhere in some... grave. And I told my son, 'When I go, I want to be put in the can with Dad.' He said, 'Are you sure?' And I said, 'Yes, I'm sure! Why not? And in the end, if that can isn't big enough, get a bigger one.'"

Carolyn and I walked around the house, looking at all their old things and talking. I imagined living alone in our house after my husband's theoretical death, and it seemed intolerably sad. I would have to move back into the office where I'd tried to write the script, the little cave. I would pick up where I had left off before I met him, when I was thirty. I would finally cook the great northern beans into a soup, and I would sit and eat that soup, alone, and then I would go to sleep, as if my entire life with him had been a single long day.

Brigitte was taking Carolyn's picture and telling her she seemed like a happy person. Carolyn agreed that she was, and then added, "You know, to be a sorry person, that's not nice. Like Dorothy always says. That's my girlfriend. I told you about her, right? We've been friends for seventy-three years."

This number startled me out of my sad tale. "So you've known her longer than Joe, then?"

"Oh yeah," she said. "Because I met her when I was seven."

I touched the glass jar containing the tiny bride

and groom from the top of Joe and Carolyn's wedding cake. Dorothy had been at that wedding. She'd probably thrown rice at her best friend. And then what did she do? How did she spend the rest of her life? I'd could call her right now and ask. It almost hurt, remembering that Joe and Carolyn were a part of the world, surrounded by an infinite number of simultaneous stories. I supposed this was one reason why people got married, to make a fiction that was tellable. It wasn't just movies that couldn't contain the full cast of characters — it was us. We had to winnow life down so we knew where to put our tenderness and attention; and that was a good, sweet thing. But together or alone, we were still embedded in a kaleidoscope, ruthlessly varied and continuous, until the end of the end. I knew I would forget this within the hour, and then remember, and forget, and remember. Each time I remembered it would be a tiny miracle, and forgetting was just as important — I had to believe in my own story. Perhaps I wouldn't live out my last days alone in my office, drinking soup and wearing black. Maybe I would live without him among the things we had made together. Not without sadness, but not only tragically.

Carolyn was putting away the photo albums and I knew it was time to go. I just had to clarify one last thing.

"I probably misheard this, but when we first talked, when you told me he had passed away, you said you kissed him and then what did you do? You

did something and then you went to the other room. You diddled...?"

Carolyn squinted into the air, remembering. "I dithered around, putting him to bed. I told him that his nose was cold and that he was a puppy dog. The rest of him was cozy because we put blankets on, you know, warm blankets. But his nose was cold, and I told him, 'Jeez, your nose is cold. You're a puppy dog.' And then I left the room."

Valentine's day,comes but once a year
And when looking for romance,you don't want a queer
So if you can't get sex,or at least a date
You must try real hard,because it is never to late
So just pop open a six pack,and have a cold beer

Cupid tries to hand out sex and love all the time
And when you push lots of glamour,thats not a crime
You get pretty women,and some really nice beaut's
That prance around in real tiny bathing suits
And they will all make love,for only a dime

This cute girl only liked oral sex,all day long
And the guys dick,could'nt be very long
So they both took all of their clothes
Then while going off to town,he did doze
And when he got to big,she cut off,half of his dong

This nymph liked to be screwed by lots of guys
And she would have sex,for a large bag of fries
She had a very large cunt
And in size,he was only a runt
So he stuck in his head,and popped out his eyes

This big sexy girl,was tremendously hot
And she had a really warm twat
He was doing oral sex,to really please
Then his stuffy nose,made him sneeze
And in nine months,she had a seven pound snot

On Valentine's day we always had goodies for the kids
And if one got more cards,the other blew their lids
We always tried to do thingson holiday's,just to have it nice
But some years we did not have much,bt it always did suffice
Most families did'nt even celebrate,they just let it go
But our kids should have had the memories,even just for show
Maybe they thought they were deprived,and were pissed off't
And when you think about it,I guess we were too soft
Now they are middle age,and growing really old
And when they look in the mirror,it turns their blood kind of cold
I think our kids don't care,or think too much of us
But we did our best,that we could,but it makes you want to cuss
Some times I just forget about it,and erase it out of my mind
But when they need us again,they will be in a big bind
We have our own life,and we must carry on
And in life we all have ups and downs,and we know that we have won
We always did with out,so we could give the kids a nice life
So in their lives,they would not have lots ofstrife
In our life we had problems,we did not expect or need
But we had to solve them,or trouble that you did not heed
We never see our kids on holidays,or any time of the year
And in an emergency,from them you would not hear
We are getting to old,to have closeness that we have lost
Our years have gone by,and the past happiness is gone at a big cost
Now that we are getting older,our ideas must come first
And if we do not think this way,our fate will be the worst
We don't ask anybody,for help in any way
And most people we know,would'nt give us the time of day
It was nice that Dorthy and BOB,helped us out
But to ask any one else,I really have a doubt
We now know that we have nobody,to depend on
So that means that we,must see that we have great bond
 So have a very nice Valentine's day
 And we are alone and together,too stay

From:Pa and all of the puppies and kitties

Our relations together ,are real strong
And we hope tha nothing,goes really wrong
We hope that neither one of us,gets real sick
And that our health,does really click
So we hope god,makes our life nice and long

When you are young,your body looke nice
But with age,it starts to pay a price
And they say youth,is wasted on the young
Though it depends,how that song is sung
But in the eye of the beholder,that should suffice

ACKNOWLEDGMENTS

Thank you to Jesse Pearson for encouraging this idea at the very start, my literary agent Sarah Chalfant for really listening, Eli Horowitz for a seventeen-step to-do list, and Starlee Kine for emboldening me to the finish. Additional thanks to Aaron Beckum for being so kind to Joe and Carolyn, going far above and beyond his duties as my assistant.

ABOUT THE AUTHOR

Miranda July is a filmmaker, artist, and writer. Her videos, performances, and web-based projects have been presented at sites such as the Museum of Modern Art, the Guggenheim Museum, and in two Whitney Biennials. July wrote, directed, and starred in the film *Me and You and Everyone We Know* (2005), which won a special jury prize at the Sundance Film Festival and the Camera d'Or at the Cannes Film Festival. Her fiction has appeared in *The Paris Review*, *Harper's*, and *The New Yorker*; her collection of stories, *No One Belongs Here More Than You* (Scribner, 2007), won the Frank O'Connor International Short Story Award. July created the participatory website learningtoloveyoumore with artist Harrell Fletcher, and a companion book was published in 2007 (Prestel). Raised in Berkeley, California, she currently lives in Los Angeles. Her second feature film, *The Future*, was released in the summer of 2011.